THE VIEW FROM WITHIN

Japanese American Art from the Internment Camps, 1942—1945

THE VIEW FROM WITHIN

Japanese American Art from the Internment Camps, 1942—1945

Karin M. Higa

JAPANESE AMERICAN NATIONAL MUSEUM

UCLA WIGHT ART GALLERY

UCLA ASIAN AMERICAN STUDIES CENTER

Distributed by University of Washington Press

ABOUT THE COVER

George Matsusaburo Hibi
Topaz WRA Camp at Night, 1945
Oil on canvas, 16" x 20"
Department of Special Collections,
University Research Library, UCLA

———————————

*Published in conjunction with the exhibition organized by the Japanese American
National Museum, UCLA Wight Art Gallery, and the UCLA Asian American
Studies Center at the Wight Art Gallery October 13 through December 6, 1992, to
commemorate the 50-year anniversary of the Japanese American Internment.*

*Major support for the exhibition has been provided by the Rockefeller Foundation, the
Nathan Cummings Foundation, the National Endowment for the Arts, the City of Los
Angeles Cultural Affairs Department, the UCLA Chancellor's Challenge in the Arts
and Humanities, the Union Pacific Foundation, and the UCLA Office of Instructional
Development.*

**Library of Congress
Catalogue Card Number:
92-061946**

ISBN 0-934052-21-2

Printed in the United States of America

Distributed by University of Washington Press
P.O. Box 50096
Seattle, WA 98145-5096

Design:	Jane Kobayashi
Editor:	Russell Leong
Photography:	Norman Sugimoto
Typesetting:	5D Studio
Printed by:	AGT/Gore Graphics

TABLE OF CONTENTS

FOREWORD

Our three institutions—the Japanese American National Museum, the UCLA Wight Art Gallery, and the UCLA Asian American Studies Center—are proud to have collaborated in organizing this historically significant and artistically magnificent exhibition. *The View from Within: Japanese American Art from the Internment Camps, 1942-1945*, is the first-ever national exhibition of paintings and other works of art produced by Japanese Americans during one of the darkest chapters in American history. In showcasing works of art which have rarely, if ever, been viewed publicly during the many decades since they were created, this exhibition captures the response to this national tragedy in a unique and profoundly moving manner.

In 1992, on the fiftieth anniversary of the World War II internment of more than 110,000 Japanese Americans, we have organized a number of activities at UCLA, in Southern California, and in communities across the nation to draw attention to this extraordinary event in our nation's past. These activities have been planned not only to enhance our understanding of what happened to Japanese Americans, but also to reveal the many responses to the internment over the years, be it through legal challenges or creative expressions. By doing so, we hope to share the significance of the internment experience with all Americans.

This important exhibition could not have been organized without the generous support of many individuals and institutions across the country. We would like to thank the major sponsors of this exhibition who shared our goal of presenting these important works of art to the general public: the Rockefeller Foundation, the Nathan Cummings Foundation, the National Endowment for

the Arts, the City of Los Angeles Cultural Affairs Department, UCLA Chancellor's Challenge in the Arts and Humanities, the Union Pacific Foundation, and the UCLA Office of Instructional Development.

We also would like to pay special tribute to the many artists and members of their families for loaning us their extraordinary works of art, and for allowing us to organize an exhibition which provides unique vantage points for understanding the internment, and unveils the rarely viewed artistic talents and legacy of Japanese Americans. We thank the Department of Special Collections, UCLA University Research Library, which houses the Japanese American Research Project Collection, for allowing us to use many of its paintings.

We hope the powerful and poignant images of the World War II internment of Japanese Americans that were captured by these artists will serve as reminders of a national tragedy that should not have happened once, and should never happen again.

IRENE Y. HIRANO
Director
Japanese American
National Museum

HENRY T. HOPKINS
Director
UCLA Wight Art Gallery

DON T. NAKANISHI
Director
UCLA Asian American
Studies Center

LENDERS TO THE EXHIBITION

Hiroko Blakeslee

The Michael Brown Collection

Heizo Fukuhara

Taneyuki Dan Harada

Shiz R. Hashimoto

Roy Hashioka

Sue and Yukio Hayashi

Estate of Hisako Hibi

Honolulu Academy of Arts

Emily Kuwada Igarashi

Japanese American History Archives

Japanese American
National Museum

Frank Kadowaki

Yo Kasai

Joe Kawakami

Dick Jiro Kobashigawa

Archie Miyatake

August and Kitty Nakagawa

Dr. Larry Nakamura

Mrs. Dan T. Nishikawa

The George and Betty Nomura
Collection

Estate of Chiura Obata

Mine Okubo

Frances Etsuko Okura

Yutaka Shinohara

Sandra Takahata

Shokichi Tokita

The Tsuruoka Family

Department of Special Collections,
University Research Library,
University of California at Los Angeles

Hisae Uno

Laura Watanuki

Nobu Yamasaki

9.

ACKNOWLEDGMENTS

A special thanks must be extended to the artists and their families who generously contributed their time and invaluable information to the development of this project: Brian and Lynn Arthurs, Hiroko Blakeslee, Diane M. Coward, Heizo and Rose Fukuhara, Henry Fukuhara, Taneyuki Dan Harada, Shiz R. Hashimoto, Roy Hashioka, June Honma, Roberta and Al Kadowaki, Kimi Kodani, Mr. and Mrs. Joe Kawakami, Ben Kobashigawa, Hideo Kobashigawa, Dick Jiro Kobashigawa, Ibuki Lee, June Mukai McKivor, Archie Miyatake, John Miyauchi, August and Kitty Nakagawa, Mrs. Dan T. Nishikawa, Penny Nishimura, Mine Okubo, Dr. Symon Satow, Yukata Shinohara, Madeleine Sugimoto, Sandra Takahata, Mr. and Mrs. Togo Tanaka, Shokichi Tokita, Haruno Tsuruoka, Kayoko Tsukada, Irene Tsukada, Hisae Uno, Laura Watanuki, and Nobu Yamasaki. Michael Brown, the Department of Special Collections, University Research Library, UCLA, Honolulu Academy of Arts, Emily Kuwada Igarashi, Seizo Oka of the Japanese American History Archives, Yo Kasai, and Frances Etsuko Okura generously lent items for the exhibition. Ann Caiger, Manuscript Librarian at the Department of Special Collections, University Research Library, UCLA, merits special thanks for her help and assistance.

The staff of the three collaborating institutions expertly guided and supported the organization of the exhibition. I am indebted to them for their support, insights, and patience. From the Japanese American National Museum: James A. Hirabayashi, Chief Curator; Nancy K. Araki, Director of Community Affairs; Chester Hashizume, Program Developer; Akemi Kikumura, Director of Program Development; Chris Komai, Public Relations Coordinator; Diane S. Nakagawa, Administrative Assistant; Dorothy E. Tanaka, Director of Volunteers; and Mary Worthington, Director of Public Programs. From the UCLA Wight Art Gallery: Elizabeth Shepherd, Curator; Cindi Dale, Director of Education and Community Development; Terry Monteleone, Director of

11.

Development; Farida Baldonado, Curatorial Assistant; Ramona Barreto, Education Assistant; Laura Cogburn, Community Development Assistant; Regina Woods, Outreach Cooordinator; Vivian Mayer, Publicist; Bryan Coopersmith, Graphic Designer; and Milt Young, Exhibit Design/Technical Coordinator. From the UCLA Asian American Studies Center: Gann Matsuda. Yoshiko Yeto and Wayne Osako provided invaluable assistance as interns. Gene Takeshita merits special thanks for his exhibition design. Patricia H. Baxter, Acting Assistant Dean, UCLA School of the Arts, provided support and guidance throughout the project.

Working with artwork that has not been exhibited previously creates new challenges. Our registrars, Grace C. Murakami and Susan Melton Lockhart, carefully coordinated the complicated registration of the exhibition with utmost efficiency. They were aided in the preparation of the exhibition by Maureen McGee, Conservation Technician, and Lynne Blaikie, Preparator, both of the Wight Art Gallery, and Pamela N. Funai, Collections Coordinator at the Japanese American National Museum.

The catalogue was coordinated by Russell Leong of the UCLA Asian American Studies Center, co-edited by Karen Jacobson, and designed beautifully by Jane Kobayashi. Lane Ryo Hirabayashi, James A. Hirabayashi, Wakako Yamauchi, and Brian Niiya provided essential contributions to the catalogue, and Brian's reading of the essays proved to be invaluable. Norman Sugimoto photographed the artworks and Jean Pang Yip proofread the text.

KARIN M. HIGA

12.

INTRODUCTION

INTRODUCTION

In the lives of twentieth century Japanese Americans, the impact of the World War II internment camps cannot be underestimated. From 1942 until 1945, more than 110,000 individuals of Japanese descent were interned in concentration camps in California, Arizona, Idaho, Wyoming, Arkansas, Colorado, and Utah after President Franklin D. Roosevelt signed Executive Order 9066 on February 19, 1942.[1]

For those former internees who are still living, their descendants, and other Americans interested in understanding the internment experience from the viewpoint of the participants, we present *The View from Within: Japanese American Art from the Internment Camps, 1942 - 1945*, an exhibition of more than 130 paintings, drawings, sculptures, and prints done by Japanese American artists during their incarceration in the camps.

15.

The View from Within began with a simple premise: that the visual record of the internment would provide insight into the mass incarceration of Japanese Americans. Through the art we would learn about the experiences of the internees and how those experiences are filtered through creativity. We expected to find a naive art that would express the trauma of incarceration and portray the daily lives and struggles of the internees. But our research revealed a different picture. The number of professional Japanese American artists exceeded our expectation. While there were a few professional artists who were known in the Japanese American community, we discovered additional artists and works in the course of our investigation. Many were professionally trained artists who actively exhibited in both Japanese American and mainstream venues and created their own artistic communities

1. There is little agreement on the terminology used to describe the incarceration of Japanese Americans. The United States government used "assembly center" to refer to the temporary detention centers, and "relocation center" to refer to the ten permanent camps which were administered by the civilian War Relocation Authority (WRA). Special sites administered by the Justice Department were called "internment camps." The term "concentration camp" was also used. Many Japanese Americans simply refer to the incarceration and the experience as "the camps" and we adopt the usage here. We also use "internment camp" and "concentration camp" as general terms.

and support networks. Our initial idea that the works represented only an emotional or political response to the incarceration was far too limited.

Accordingly, what started as an investigation of the visual record of the historical moment of the internment expanded to include an examination of the artists themselves and their visions. In addition to looking at the art made during incarceration as the expression of individuals caught in the struggle of human rights, the exhibition aims to uncover the individual artists and their histories. Who were these artists? What were their lives like? How did they make work? What were their reactions to the incarceration? The exhibition takes as its starting point the internment, but in the end it tells us as much about the art and experiences of the artists as about the history of the event.

With one exception, the works in the exhibition were executed between 1942 and 1945, corresponding to the period of mass incarceration. All the works were made in temporary assembly centers, War Relocation Authority relocation camps, Justice Department/FBI internment centers, or military detention camps, such as those operated on the Hawaiian Islands. The artists included are predominantly Issei who immigrated to America between 1900 and 1924. A few are Kibei, America-born, educated in Japan, and fewer still are Nisei, second generation Japanese Americans. These distinctions are important in recognizing the relative positions and circumstances of the artists as well as their influences. For practical reasons, the focus has been limited to paintings, drawings, printmaking, and sculpture, despite the presence and activity of craft, folk, and commercial artists in the camps and their noteworthy accomplishments.

The biggest obstacle in organizing an exhibition of this kind is finding the art. For every painting or drawing saved, many others were lost. For every artist included in this exhibition, there must be others who have not been identified or acknowledged. In researching the exhibition, we found that casual conversations would yield terrific finds. One person's aside, "My uncle is an artist" would open the door to art rarely seen and never exhibited. The work of Kenjiro Nomura was thought to be lost until his son found a bundle of paintings and drawings in the family garage, more than twenty years after the artist's death.[2] Other families

2. The "discovered" works of Nomura were the subject of *Kenjiro Nomura: An Artist's View of the Japanese American Internment*, organized by the artist's niece, June Mukai McKivor, for the Wing Luke Asian Museum in Seattle in 1991.

remember seeing artwork, but because of the silence that has surrounded the subject of internment, those interned may have little idea of its place of origin or significance. A conscious effort has been made to exhibit a wide range of art from all the camps, but the limitations of our artists and artwork will become apparent as more artists and their families come forward.

Moreover, had the exhibition been mounted a mere five years ago, many of the artists would have still been alive. With their passing, a valuable source of history has been lost. One currently fashionable school of historical methodology regards the artists' experiences and ideas, and intentions as extraneous to the reception and interpretation of the artwork itself. Many other scholars, however, are pursuing investigation and analysis of art created by individuals outside of the mainstream. Like the works of other "outsider" artists, the art made by Japanese Americans has been largely ignored, and in many cases was not known to exist at all. Investigation of the voices, personal histories, and intentions of the artists is therefore all the more essential to an understanding of their lives and works.

17.

The exhibition aims to be panoramic in scope, including work by professional as well as amateur artists. To facilitate analysis of the art made during incarceration, however, the works in the exhibition are roughly divided into several groupings. The first group includes artists associated with the professional art schools established in the camps, followed by an investigation of individual artists. A second group includes artists whose work was primarily documentary in nature. A final grouping consists of art made by those who considered art as an avocation rather than their primary pursuit. For this catalogue, fifteen artists have been selected for greater discussion. They represent a range of artistic styles and working methods and reflect the diverse responses and manifestations of creativity.

The View from Within is not the first exhibition of art made in the camps. There have been a number of small exhibitions and displays, organized primarily by community-based groups such as the Japanese American Citizens League, and by university ethnic studies departments such as San Francisco State's Asian American Studies Department. In two cases, non-ethnic-specific institutions mounted exhibitions. The California Historical Society organized *Months of Waiting 1942 - 1945,* which was conceived as a companion exhibition to *Executive Order 9066,* an exhibition of photographs on the internment camps which opened at the M. H.

De Young Memorial Museum in 1972. *Executive Order 9066* was re-exhibited at the UCLA Wight Art Gallery in February 1992, as part of the fifty-year commemorative activities of the internment organized by the UCLA Asian American Studies Center. The Oakland Museum's education department mounted a small exhibit in the fall of 1976. However little documentation exists from these exhibitions, and all emphasized the history of incarceration rather than the art.

In addition, although there has been a large body of scholarship in recent years devoted to the history, literature, oral histories, and the psychological and sociological implications of incarcerated Japanese Americans, little attention has been paid to the arts and artists. Notable exceptions include Allen H. Eaton's early work, *Beauty Behind Barbed Wire* (1952) which provides a detailed account of the arts in the camps, specifically crafts, and a recent book by Deborah Gesenway and Mindy Rosen, *Beyond Words: Images from America's Concentration Camps* (1987). Eaton's exploration of the relationship of traditional Japanese craft techniques to those employed by Japanese Americans in the camps is of particular interest; and Gesenway and Rosen's emphasis on the oral histories and stories of camp artists is invaluable. These two groundbreaking resources only begin to suggest the range and complexity of creativity during internment.

It is our hope that this exhibition and catalogue will add to an ongoing examination of the visual record of internment, encouraging further analysis of the art and artists. It should be seen as a modest step in the increased understanding of Japanese American artists and Japanese American history, and we thank the authors for their contributions.

To supplement my essay on the exhibition, Lane Ryo Hirabayashi and James A. Hirabayashi in their essay have provided an historical overview of the Japanese in America and some of the political and societal events leading up to, and following the incarceration. Their overview, accompanied by a chronology of the internment by Brian Niiya, set the stage and context for an examination of the artists and their art. In her numerous short stories and plays, Wakako Yamauchi has delved into the psychological milieu of Japanese Americans, revealing the struggles, conflicts, and moments of resolution in the process of becoming an American. For this catalogue she has written a personal meditation on the camps and her memories of creativity in the southern Arizona desert.

18.

THE VIEW FROM WITHIN

Karin M. Higa

THE VIEW FROM WITHIN

Karin M. Higa

"We believe that art is one of the most constructive forms of education.

Through creative endeavors and artistic production,

a sense of appreciation and calmness is developed, and in consequence,

sound judgment and a fine spirit of cooperation follow." CHIURA OBATA [1]

These words, written by artist Chiura Obata in the spring of 1942 while organizing the Tanforan Art School, speak to the fundamental role of creativity for Japanese Americans incarcerated during World War II. Faced with confusion and uncertainty in the wake of Executive Order 9066 and the subsequent mass evacuation from the West Coast, Japanese American artists such as Obata laid great faith in the power of the creative spirit and its ability to provide hope to individuals as well as an entire community.

The Tanforan Assembly Center in San Bruno, California, was the temporary detention camp for Japanese Americans in the San Francisco Bay Area. It was a racetrack and stable that had been only modestly modified to house over eight thousand internees, representing the second largest of the fifteen Assembly Centers scattered throughout the West Coast. On May 19, 1942, a mere twenty days after their arrival at Tanforan, a group of Japanese Americans, many of them artists, finished cleaning and scraping the muddy floors and dusty walls of Mess Hall #6. Registration for the Tanforan Art School was to begin that day.[2]

1. From "Tanforan Camp Art School," papers of Chiura Obata. Courtesy of Estate of Chiura Obata.
2. Information about the school, its curriculum, instructors, and exhibits comes from the papers of Chiura Obata. Courtesy of Estate of Chiura Obata.

By the time the art school opened its doors six days later on May 25, 1942, the former racetrack building had been transformed into a comprehensive art school offering more than twenty-five subject areas including figure drawing, landscape, still life, mural painting, anatomy, sculpture, art appreciation, fashion design, interior decoration, cartoon drawing, architectural drafting, and commercial layout. The school was led by Chiura Obata, who had joined the art faculty of the University of California at Berkeley in 1932. Obata spearheaded a curriculum that offered sequential class offerings at five levels—elementary, junior high, high school, junior college and college, and adult education. There were ninety-five classes per week running from 9 A.M. to 9 P.M. daily. Students ranged in age from six to over seventy years old.

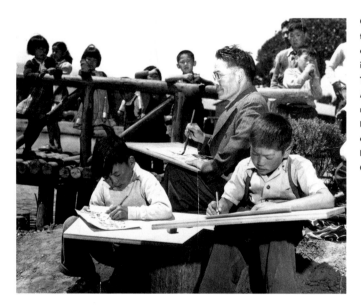

Chiura Obata teaching art classes in the infield of the Tanforan Assembly Center race track, 1942. Photograph courtesy of Estate of Chiura Obata.

The school was a place both of recreation and serious study. For many in Tanforan, the art school provided a way to pass the undifferentiated spans of time. For others, especially young adults and children, the school provided early exposure to art, art making, and artists. Contemporary fiber artist Kei Sekimachi recalls her early training in Tanforan and the respect and admiration she had for her instructors. The school managed to mount exhibitions of the instructors' and students' artwork, both in and outside of the assembly center. From June to September 1942 there were exhibitions of Tanforan-made art at International House and the YWCA in Berkeley, Mills College, and the Pasadena Art Institute. In August, when the school held a three-month anniversary exhibition at the assembly center, more than three thousand people attended, nearly forty percent of the total population.

Clearly an endeavor of this scope and scale required the support and cooperation of many people. Obata was able to secure the approval of the assembly center administration to begin the school, and used his many contacts in the "outside" world to gather donations of supplies and materials. In many cases he was assisted by his former students and colleagues who often visited and delivered supplies in person. But the most essential component in the formation of an art school is the teacher. Tanforan was unusual in the number of professional artists interned, since the San Francisco Bay area was home to a significant group of Japanese American artists. There were sixteen artist-

Chiura Obata
Talking through
the Wire Fence,
1942
Sumi on paper,
11" x 16"
Estate of Chiura
Obata

instructors in all and although it is unclear as to the extent to which these artists knew each other before incarceration, once interned they joined forces with Obata to help with the art school.

Obata enjoyed a unique stature as both an artist and a member of the Japanese American community. Born in Sendai, Japan, in 1885, Obata immigrated to San Francisco in 1903. He began his artistic training in Japan at the age of seven, studying painting under the tutelage of several masters of the Shijyo, Kano, and Tosa schools at a time when the influence of Western painting was strong.[3] He worked in the Japanese *Nihonga* style, which represented an innovative fusion of *sumi-e*, traditional Japanese ink painting, with Western concepts of naturalism and an expansion of the color palette. Obata was particularly interested in the California landscape, taking inspiration from excursions made to locations such as Yosemite. His work of the prewar period captures the grand scale and monumentality of the Western landscape using line and broad washes of ink to evoke mood rather than documenting specific locales. By the time of evacuation, he had participated in

3. James H. Soong, "Introduction to the Obata Retrospective," in *Chiura Obata, A California Journey* (Oakland: Oakland Museum, 1977), 3.

over sixty exhibitions including some twenty-five solo exhibitions at institutions such as the Honolulu Academy of Arts (1930), the M.H. De Young Memorial Museum (1932), and the Crocker Art Gallery (1938). His extensive schedule of exhibitions, as well as his teaching position at Berkeley made him a prominent figure in both the Japanese American and arts communities.

Obata remains the most Japanese of the artists in the exhibition. However, with evacuation Obata's work becomes much more

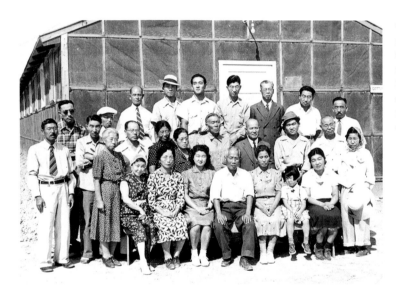

Group photograph of the Topaz Art School, c. 1943. Photograph courtesy of Estate of Chiura Obata.

documentary in nature. He continued to use the medium of *sumi-e*, but used it to illustrate and record events both seen and experienced. *Talking Through the Wire Fence* (1942), made shortly after the evacuation, depicts an early experience of visiting with students and friends through a high wire fence at Tanforan. According to a 1986 recollection of his widow, Obata's students exclaimed, "Oh, how terrible Professor Obata, you are behind a fence!" To which Obata replied, "From my perspective it looks like you are behind the fence."[4] In *Two Angels in the Rain — the First Students of the New Art School* (1942), young girls wait on the steps of the art school building under a eucalyptus tree branch. A furious storm raged on the day of the opening of the art school, and Obata worried that attendance would be hindered. When he approached the building, he saw the young students waiting, drenched from the rain. "In my heart, I thanked the mothers for their bravery in sending their beloved children even in such storms. I thanked Heaven for having started this movement."[5]

4. From an oral history of Haruko Obata by Kimi Kodani, 1986. Courtesy of Estate of Chiura Obata.
5. From the papers of Chiura Obata. Courtesy of Estate of Chiura Obata.

These works suggest two important views put forth in Obata's art: the necessity of maintaining perspective and the never ending cycle of change; and an unwavering faith in the power of creativity to better the life of the artist as well as the lives of fellow internees. His choice of subject matter highlights the ways in which internees continually sought to make the best of the situation. Without offering a direct commentary on the legitimacy or illegitimacy of internment, Obata's work succeeds in evoking sympathy, compassion, and respect for the plight and perseverance of the internees. Interestingly, when Tanforan was closed and the internees moved to Topaz Relocation Center, Obata returned to depicting the landscape in addition to his more documentary work. He captured the wide expanses of Utah and the intense colors of the desert sunsets in *Sunset, Water Tower, Topaz* (1943), including the water tower as if to remind us that he was indeed interned.

The Tanforan Art School moved along with the internees, reopening as a division of the Topaz Adult Education Program. Obata continued to provide leadership to the school until he was released from Topaz and moved to St. Louis in 1943 as part of the War Relocation Authority's early relocation program. George Matsusaburo Hibi took over the leadership of the school. Like Obata, Hibi was born in Japan, in Shiga Prefecture in 1886. In artistic style, however, Hibi and Obata could not be further apart. While Obata maintained an aesthetic adherence to Japan, Hibi embraced the West, even adopting the name "George." Hibi was fascinated with the art of Cézanne and the Post-Impressionists, teaching a class at Topaz called "History of Western Art." The class description read: "lectures in history of Western art and especially on the movement of modern art."

Hibi immigrated to Seattle in 1906, staying there and in Los Angeles before settling in San Francisco. In 1919 Hibi entered the California School of Fine Arts (now the San Francisco Art Institute) and studied there for eleven years. From 1922 until evacuation, he participated in annual exhibitions of the San Francisco Art Association, the Oakland Gallery, and the California Palace of the Legion of Honor. He married Hisako Shimizu, a fellow art student, and moved to Hayward, California in the early 1930s

25.

where they ran a Japanese language school while continuing to paint and exhibit. Unfortunately, the location of most of his pre-war paintings are unknown. Just prior to the evacuation, Hibi donated fifty of his paintings and prints to local hospitals, schools, libraries, and public halls of Hayward. As reported in the April 7, 1942, edition of the *Oakland Tribune*, Hibi declared: "There is no boundary in art. This is the only way I can show my appreciation to my many American friends here."

While his paintings resist any overt critique of the internment, they remain powerful in their subtlety and ambivalence. *Going for Inoculation* (1942) hints at the early confusion of incarceration and the new found experience of living among so many in such close quarters. A long line of people, of small stature, wait amid the imposing structures of Tanforan. The act of inoculation takes on new meaning when considering the forced circumstances. Japanese Americans are undistinguished as individuals and must adhere to the requirements, rules, and routines of the new officials.

26.

The coyote was often present in Hibi's Topaz, as a real entity and a figurative symbol. In *Topaz WRA Camp at Night* (1945), we see what appears to be a distant city protected by a fence from prowling coyotes. The nighttime scene is serene and calm. Yet the questions remain: Who is free in this picture? The fence is there to protect, but to protect whom? The painting refers to one of the common justifications for the incarceration: that the camps were there to *protect* the Japanese Americans. The coyotes are on the outside, yet they are free. The "city" lights are in fact the lights of internment camp Topaz, an artificially constructed site which had the largest population in central Utah. Hibi was both an artist and an internee, and as the viewpoint of the painting suggests, he could be simultaneously inside and outside of camp.

Perhaps *Men Painting, Sunset, Topaz* (1944) best exemplifies the ambivalent predicament of many of the artists in camp. Four men sit in front of easels, painting the desert sunset. In the distance the blurred outline of the barracks is barely visible. The viewer is

drawn instead to the intensity of the sunset and the casual yet serious posture of the men. These painters are focused on trans-forming their situation into art. The power of creativity overcomes the incarceration. Likewise, Topaz provided Hibi the uninterrupted time to paint, and as the director of the art school, he was able to unite his work life and artistic life in a way that he had not been able to before.

Hisako Hibi was also an artist. Considerably younger than her husband, she was born in Japan in 1907 and came to America as a teenager. She met and married George Hibi while a student at the California School of Fine Arts. When not taking care of their two young children, Hisako taught the children's art classes at Tanforan and Topaz. Perhaps because of her roles as a mother and a teacher of children, Hibi's most successful work explores domestic situations in camp. The barrack bathing and toilet facilities were notoriously poor. Communal latrines meant little privacy and long waits. Ingenuity became a necessary requirement for survival. The laundry room in Hibi's 1943 painting of the same name looks more like a bathroom.

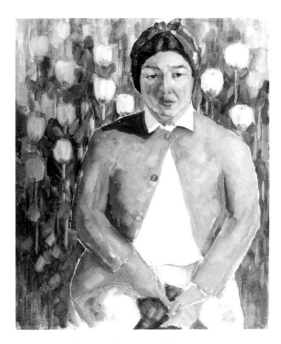

George Matsusaburo Hibi
Hisako, Wife, 1943 - 1944
Oil on canvas, 26" x 22"
Estate of Hisako Hibi

With only four baths for an entire block, mothers bathed their children in the laundry room. An open door at the rear of the room reveals rows of barracks beyond, reminding us of the context of this scene. The ingenuity of the mothers in adapting to their situation mirrors her own position as an artist in camp.

Like her husband, Hibi was inspired by the work of Western painters of the late nineteenth century, in particular the work of Mary Cassatt. In *Homage to Mary Cassatt* (1943) the circle of influences is completed. A Japanese American mother bathes a child

in a direct reference to Cassatt's *The Bath* (1892). Hibi, a Japanese American artist, paints a homage to Cassatt, a Western artist who was herself influenced by Japanese wood block prints.

The teachers at Topaz had a range of opinions and working styles, all of which influenced their young students. One of the instructors was Byron Takashi Tsuzuki. Tsuzuki immigrated directly to New York from Japan at the age of sixteen. He studied at the Art Students League in the 1920s, participated in annual exhibitions of the Society of Independent Artists, and eventually became a director of the Salons of America along with his friend and colleague Yasuo Kuniyoshi before moving to the San Francisco area in the 1930s. Tsuzuki's affinities lay with the artists of the Ashcan school. At Topaz, he and George Hibi often engaged in heated discussions about their differing artistic sensibilities. Taneyuki Dan Harada received his first artistic training at Tanforan and Topaz. Harada's teacher was George Hibi, who discouraged the students from using small brushes in an attempt to work on larger planes. Although the school was located near a guard tower and the barbed-wire fence, Harada recalls that he found it awkward to paint the legs of the tower with a large brush and therefore chose not to depict the tower at all. Attention to the lessons of art superseded the need to document his surroundings.

Another artist affiliated with the Tanforan and Topaz art schools was Mine Okubo. Okubo was born in Riverside, California, in 1912. She attended the University of California, Berkeley where she received her bachelor's and master's degree in art, with a course of study emphasizing fresco and mural painting, not the traditional Japanese techniques taught by Obata. After receiving the school's prestigious Taussig travel scholarship in 1938 which afforded her a two-year stay in Europe, Okubo returned to Northern California and participated in the Federal Arts Program, completing murals at Fort Ord, Oakland Hospitality House, and Government and Treasure Islands. Immediately after evacuation Okubo began a series of pen and ink drawings that would ultimately form the basis of her book, *Citizen 13660*, originally published by Columbia University Press in 1946. The title refers

ironically to her status as a citizen, juxtaposed with the number she was assigned during evacuation. The drawings provide a detailed account of her experiences accompanied by a running text. Okubo uses humor to indict her jailers, eliciting sympathy and compassion through her depiction of everyday life in the camps.

A series of charcoal drawings including *Mother and Children* (1943), expressionistically portrays the despair and weariness of the internment experience. The directness and overt emotional content of Okubo's charcoal drawings suggest her more secure status as a citizen. Unlike George Hibi and Chiura Obata, Okubo was an American by birth and sensibility, and her citizenship granted her certain privileges. Yet in 1944, when the editors of *Fortune Magazine* saw *Trek*, a camp publication collaboratively organized by Okubo and several writers including Toshio Mori, they asked Okubo to come to New York to illustrate the April 1944 edition of their magazine which focused on Japan. Ironically Okubo, who had never visited Japan, was asked to interpret the country for *Fortune's* American readers.

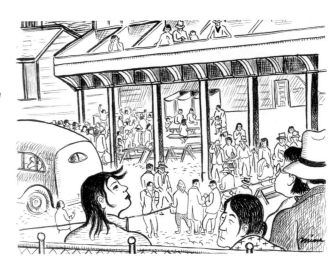

Mine Okubo
The grandstand was used as the induction center - 300 to 350 evacuees arrived each day, **1942**
Ink on rice paper, 8.5" x 11.5"
Collection of the artist

The art made in Topaz was not restricted to the work of the instructors. Yoshiko Yamanouchi and Seizo Murata were amateur artists. Both have long since passed away, and we have no idea whether they were students at the school, or how they came to make their art. Other artists, such as Charles Erabu (Suiko) Mikami and Chikaji Kawakami, were quite prolific and accomplished. Mikami's watercolors represent the barrack landscape, generally unpopulated except for a few lone figures. According to his son, Kawakami was largely self-taught and worked independently of any school or group.

The differences between the art of those affiliated with the Topaz school, and the presence of art by those who were not, begin to suggest the tremendous range of artistic activity within the confines of one camp, making it impossible to generalize about a single style or method of working. While Tanforan and Topaz were perhaps the most sophisticated schools in scope and scale, and unusual in the high concentration of professional artists, they were not alone in using the arts to provide a "home" to artists and a creative release for the internees. On a much smaller scale, Tokio Ueyama taught art classes to adult students in Amache, an internment camp located in central Colorado. Although little information about the school exists, a photograph taken at the time shows serious students at work in front of easels, painting from a live model, in this case fellow student Shunichi Hashioka.

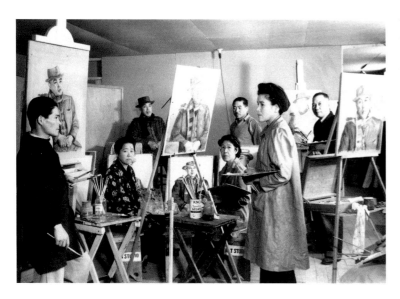

Tokio Ueyama and students at the art school at Amache (Granada), c. 1943. Photograph courtesy of Roy Hashioka.

Ueyama was born in Japan in 1889, immigrating to the United States in 1908 to attend art school in San Francisco. He entered University of Southern California in 1910 and graduated four years later with a degree in fine arts. After a few years living in Los Angeles, Ueyama entered the Pennsylvania Academy of Fine Arts in Philadelphia. In 1919, he received the Academy's Cresson travel scholarship and spent the following year in France, Germany, Italy, and Spain. After returning to Little Tokyo in Los Angeles, Ueyama and friends T.B. Okamura, a poet, and Sekishun Uyena, a painter, formed Shaku-Do Sha, an association of Japanese artists "dedicated to the study and furtherance of all forms of modern art."[6] Based in Little Tokyo, Shaku-Do Sha acted as a support group for artists of various

6. From a July 7, 1927 article in the scrapbook of the artist.

disciplines, including photographer Toyo Miyatake, and was responsible for organizing several exhibitions of the work of Japanese American artists each year. But the group also supported artists outside of the Japanese American community. In 1927, when Edward Weston returned from an extended stay in Mexico, Shaku-Do Sha sponsored an exhibition of his photographs taken in Mexico in a Little Tokyo storefront. Ueyama himself had traveled to Mexico in 1924, and it is possible that Ueyama made contact with Weston at that time.

Ueyama was technically accomplished and worked in an academic style that focused on realistic depictions of the Amache landscape. The complete absence of conscious commentary on the incarceration in his painting is noteworthy. Ueyama focused on what was formally dynamic. Yet his 1942 painting *The Evacuee* captures a quiet moment of normalcy and contemplation that in many ways sums up the experience of camp. A woman, Ueyama's wife, sits crocheting in the doorway of a barrack. Inside are the little objects that signify a home. Beyond the open door are rows of barracks. The woman is focused on her crocheting, but her posture hints that perhaps she is thinking of something else. Neither happy nor distraught, she simply exists at that instant, within the confines of her barrack home and physical parameters of camp, yet able to overcome these circumstances by the force of normalcy.

31.

The call to help with art education was heard beyond the camps, inspiring sculptor Isamu Noguchi to participate. At the time of evacuation, Noguchi lived in New York and was therefore outside the Western Defense Command zone. In the spring of 1942, Noguchi participated in a meeting of "creative people of Japanese extraction" held in the New York City studio of Yasuo Kuniyoshi.[7] The purpose of the meeting was to discuss ways to help the internees. Noguchi later wrote of the meeting, "they all wished to be able to participate as visiting artists, teachers or lecturers."[8] With the encouragement of John Collier, Commissioner of

7. Letter to Mrs. Adams, June 15, 1942. From the WRA case file of Isamu Noguchi.
8. *Ibid.*

Indian Affairs for the Department of the Interior, Noguchi voluntarily submitted to incarceration on May 8, 1942, so that he "might contribute toward a rebirth of handicraft and the arts which the Nisei have so largely lost in the process of Americanization."[9]

Once interned in Poston, Noguchi found it difficult to mobilize arts instruction and craft apprentice guilds. By July of 1942, only three months after his arrival, Noguchi finally gave up and began the long process of seeking release. His idealistic desire to "fight for freedom" through creative endeavors was frustrated by the bureaucracy of the camp administration and his incompatibility with the interned Nisei.[10] The desert heat, the difficult living conditions, and the restrictions on his freedom left Noguchi embittered.[11] Noguchi entered Poston as a well-known and well respected artist, but once interned he was simply another incarcerated Japanese American. He sought permission to leave Poston to work in San Francisco but was denied it on the basis of ethnicity despite the references listed on his permit to leave form which included: John Collier; Francis Biddle, Attorney General of the United States; and Henry Allen Moe, Secretary of the John Simon Guggenheim Memorial Foundation.[12] He was released to return to New York in the spring of 1943. No art from this period of Noguchi's career has survived, though we know through anecdotal information that he sculpted from the hardwood available throughout Poston.

Although Noguchi could not realize his vision, there was art made at Poston. Kakunen Tsuruoka painted the Arizona desert, depicting the Southwestern desert landscape in a distinctly Japanese style. Harry Yoshizumi painted his surroundings in watercolors, Frank Kadowaki in small oil paintings. Perhaps Noguchi's experience is most useful in understanding the difficult circumstances of internment and traits necessary for survival. The seeming ease with which the art schools were established in other camps belies the camp reality where survival meant compliance, and intense idealism was tempered by a realization of the limitations.

32.

9. Letter to Mr. Fryer, July 28, 1942. From the WRA case file of Isamu Noguchi.
10. Letter to John Collier, July 27, 1942. From the WRA case file of Isamu Noguchi.
11. *Ibid.*
12. Form WRA-71, Application for Permit to Leave a Relocation Center for Private Employment, undated. From the WRA case file of Isamu Noguchi.

While the art schools provided many internees with their only opportunity to make art, there were also many artists who found jobs in camp that enabled them to continue working. Henry Sugimoto taught in the camp secondary schools, first as the advisor to the high school students at Jerome and later at Rohwer, Arkansas. He was born in Japan in 1900 and joined his parents in central California after completing middle school in Wakayama. He studied art at Berkeley before transferring to California College of Arts and Crafts. By the time of the evacuation, Sugimoto had been painting for close to twenty years. He traveled to Europe in 1929, making an extended stay in Paris, where he participated in the 1931 Salon d'Automne. He exhibited at the California Palace of the Legion of Honor (1933), and at the Nika-kai Annual Exhibition in Tokyo (1937) and was invited to participate in the Pittsburgh International Exhibition in 1941 when war broke out. With evacuation, more than one hundred of his prewar paintings entrusted to a San Francisco gallery were never seen again.

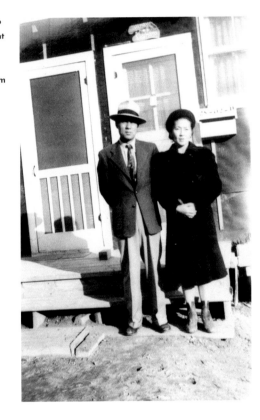

Henry Sugimoto and wife in front of barrack, c. 1943. Photograph from the Madeleine Sugimoto Collection, Japanese American National Museum.

In the camp, Sugimoto's two biggest obstacles to making art were the lack of supplies and the fear of the authorities' reaction to his painting. He managed to bring a few tubes of paint, a couple of brushes, and a small bottle of turpentine to the Fresno Assembly Center. Since he did not have canvas or paper, he used anything he could find: sheets, pillowcases, a mattress bag. And he painted secretly. In a 1982 interview he said:

One time an army lieutenant came to my place and said, "I want to take your picture inside your apartment." Perhaps on the outside he already heard I am artist, painting inside. So he came in: "I want to take your apartment picture." Inside I got paintings, still I'm painting, you know. That's why he told me: "We want to take movies. You do your work. Your wife bring to you some tea." Me, my wife—like actors. I am painting. My wife bring tea; serving the tea. Then they took movie. Then they took another movie in the mess hall. We went to lunch. On the corner table, so much good, chicken and all, like we never eat before here. They let them film to make record, you know. I ask lieutenant, "What are you going to do with those movies you took at my place?"

"That's only government record. In case it's needed, maybe they show it—we treat Japanese like this: artist, some people teaching school—very free and happy." That's our government record. That's why they let me act like that.[13]

34.

After this experience, Sugimoto felt free to paint, and he was known throughout camp as an artist. Above his barrack door was a wooden sign in the shape of an artist's palette with the name Sugimoto carved in relief. His barrack became a studio. His job in the high school enabled him to request materials that he needed to make his own work, including oil paints and canvas, "that's why I started all the paintings. The government gave to me."[14] A self portrait painted in 1943 sums up the triumph of Sugimoto's identity as a working artist. Wearing a beret with palette in hand, he stands in front of an easel. Two paintings are visible in the background. On the right is one of Sugimoto's prewar European landscapes and on the left, a still life painted at Fresno Assembly Center. Nothing, other than the title *Self Portrait in Camp*, suggests that the artist is interned.

Most of Sugimoto's work, however, is characterized by an emphasis on visually complicated, highly charged scenes of camp life. *Rev. Yamazaki Was Beaten in Camp Jerome* (1943) depicts a real life event. When Rev. Yamazaki acted as a Japanese language translator for the government's loyalty questionnaires in February 1943, he was thought to be an agent of the American government and

13. Deborah Gesensway and Mindy Rosen, *Beyond Words: Images from America's Concentration Camps* (New York: Cornell University Press, 1987), 35-37.
14. *Ibid.*, 37.

therefore responsible for the ensuing separation between the "loyal" and "disloyal." The painting is unusual in its representation of the tensions and divisions within the camps brought to head by the questionnaires. Rev. Yamazaki's resemblance to a Christ figure is clearly articulated. An electric wire post above the reverend's head forms a cross, and his body, held by one of his attackers, suggests Christ on the cross.

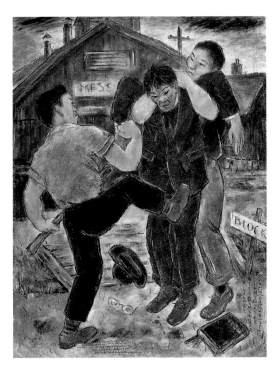

Henry Sugimoto
Rev. Yamazaki
Was Beaten in
Camp Jerome,
1943
Oil on canvas,
39.25" x 30.25"
Japanese
American
National
Museum

Sugimoto's brother Ralph was drafted before the war and eventually served as part of the 442nd Regimental Combat Team, an all-Nisei unit of the United States Armed Forces. Along with the 100th Battalion, which was composed of Nisei from Hawaii, the 442nd became the most decorated unit in United States military history for the size and length of service. In many of his paintings, Sugimoto explores the ironies of the Nisei soldiers who fought while their families remained interned. A portrait of his mother (1943) shows the colors and symbols of the 442nd in the background with her weary face embodying the toll of internment and a son in war. *Old Parents Thinking about Their Son on the Battlefield* (1943) depicts Issei parents in front of a barrack, with an image of their son hovering between them. The son, proud in army uniform, stands in stark contrast to the dark and gloomy predicament of his parents.

Sugimoto's longtime friend Sadayuki Uno was also interned at Fresno Assembly Center, Jerome, and Rohwer. Uno was born in Japan in 1901 and came to the United States to join his father who had immigrated a few years earlier. After finishing high school in Oakland, he received a scholarship to the California College of Arts and Crafts. He stayed at the art school for a few

years before heading east, first to Chicago and then on to New York where he enrolled in photography and cinematography school. He returned to the Oakland area in the late 1920s upon hearing of the illness of his father. He made his living as an interior decorator and as the economic climate of the Depression worsened, he found work as a gardener. He painted throughout this time period.

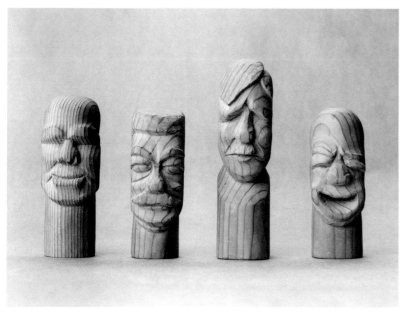

Sadayuki Uno
***Mussolini, Stalin, Hitler and Churchill,* 1942**
Carved pine, each 4" x 2" x 2"
Collection of Hisae Uno

At Fresno Assembly Center Uno took up carving. With no tools or equipment to speak of, internees were forced to use butter knives and other modified carving implements. One of his first projects was five small carved pine sculptures. Each stood only four inches high and depicted major leaders of the warring nations: Mussolini, Stalin, Hitler, Churchill, and Roosevelt. The tone is at once serious and humorous, simultaneously presenting a caricature and an understanding of their power in world affairs. The sculpture of Roosevelt was given to an admiring administrator at the assembly center, leaving only four remaining pieces. Not surprisingly, Emperor Hirohito is conspicuously absent. Any depiction of the Japanese emperor would have arose suspicion and distrust.

For Uno the internment represented the most prolific period of his artistic life. He painted, carved sculpture and wooden masks, and took up *shigin*, a Japanese form of spoken poetry. His art captures both the humorous aspects of camp life and serious

moments of inner despair. In his untitled painting of men playing cards (1944), Uno shows us a behind-the-scene look at the

camp firehouse, where gambling, smoking, and jokes were the norm. In contrast, his *Portrait of Nishida* (1942), painted on a potato

sack and framed in wood from a celery crate, is more somber in tone. It was rumored that Nishida was a spy and former Japanese

military man. He was deemed suspicious and transferred to another camp by the FBI. With the hysteria brought on by the

bombing of Pearl Harbor, many fell under government suspicion as potential threats to national security, sometimes by their mere

affiliation with Japanese immigrant clubs and prefectural associations. Despite the United States Justice Department's concern

about traitors and spies, no evidence exists to support the assertion that the Japanese Americans harbored a security risk. The

dark, inward focus of Uno's portrait of Nishida does not reveal any verdict as to the sitter's innocence or guilt. He remains a

noble, seemingly harmless man caught in the confluence of world politics.

Artists Kenjiro Nomura and Kamekichi Tokita were friends and colleagues before the war. In the 1920s, they were partners in

Noto, a sign-painting business located in the International district of Seattle. Nomura immigrated to America with his family at

the age of ten, and when they decided to return to Japan six years later, he stayed. In 1921 he began formal art training with

Dutch painter Fokko Tadama. Tokita was born in Japan in 1897, arriving in the United States in 1919 with the original inten-

tion of working in the tea business. After starting the sign shop, Tokita became interested in oil painting and studied with his

partner Nomura.

Beginning in 1928, Nomura and Tokita began exhibiting professionally. Their works were included in the annual exhibitions of

the Oakland Art Gallery, the San Francisco Art Association, and the Seattle Art Museum. In 1933 Nomura had a solo exhibition

at the Seattle Art Museum, and later that year his paintings were included as part of the New York Museum of Modern Art's

Painting and Sculpture from Sixteen American Cities. By 1936, Nomura and Tokita had closed the sign painting business after struggling

with the economic downturn brought on by the Depression, but both continued to flourish as fine artists. In 1937 Tokita and

Nomura were part of a loosely formed association called the "Group of Twelve" which included artists Kenneth Callahan and Morris Graves. Once interned at Minidoka, Nomura and Tokita "opened" a sign painting shop housed in warehouse 20. They continued to make art using whatever materials they could find, from beaver board to canvas. Unfortunately, Tokita's paintings were given away or lost, and only a few remain. Nomura's paintings were considered lost until his son found them in the family garage in the 1980s.

For some of the artists, the art made during incarceration represented continuation of an individual vision without any conscious commentary on the circumstances of incarceration. For others the art was a means of recording events and incidents. The photographer Kango Takamura saw himself as a documentor, replacing the forbidden camera with his artistic talents. Takamura immigrated first to Hawaii, and then on to the mainland. After a few years in Southern California, he decided to try his luck in New York where he worked for Paramount and Lasky studios. He returned to Hollywood with the hope of becoming a camera man. As a child, Takamura wanted to be an artist, but after seeing an exhibition of "modern" art in Hawaii, he decided that photography better suited him as an art form.[15]

Immediately before the attack on Pearl Harbor, Takamura worked as a photo retoucher at RKO studios in Hollywood. Three weeks before the bombing, his supervisor at RKO studios had taken an order for two movie cameras from a Japanese army officer. The order was later canceled, but because Takamura had had dinner with the Japanese officer, he was unwittingly under suspicion. In February of 1942 he was taken away by the FBI. After four days in a city jail, he and other Japanese Americans were bused to a former boy scout camp in Tujunga Canyon. Ten days later they were put on a train to New Mexico, where they were interned at the Justice Department/FBI Santa Fe internment camp. He remained in Santa Fe for nearly five months, until he was released to join his family in Manzanar.

38.

15. *Ibid.*, 128-129.

The fear of censorship was always present, though many artists did not explicitly articulate their concerns. For Takamura the purpose of his drawings and watercolors was to document and record, and he was fully aware of the implications of this when he began to draw.

Enemy aliens were not allowed to carry cameras with them anytime, anywhere.... At first I drew in a cartoon style to avoid troubles, but no one bothered me. So I became bold and depicted the life in camp as realistically as possible.... Whenever possible, I sketched the life in camp. The drawings were like photographs.[16]

The use of humor to explore politically and emotionally laden issues was not unusual. In *Our Guard in the Watchtower Became a Spring Baseball Fan* (1942), a group of internees play baseball while a guard cheers from the tower above. What initially appears to be an innocuous depiction of fun and games becomes complicated when the presence of the guard and

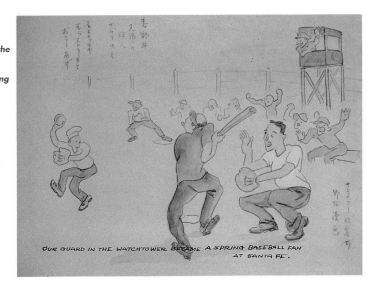

Kango Takamura
Our Guard in the Watchtower Became a Spring Baseball Fan, 1942
Watercolor on paper, 8.5" x 11"
Department of Special Collections, University Research Library, UCLA

OUR GUARD IN THE WATCHTOWER BECAME A SPRING BASEBALL FAN AT SANTA FE.

barbed wire fences is considered. His ironic sense of humor carries over to watercolors made in Manzanar. *Progress after One Year, the Mess Hall Line* (1943) comically depicts a long line leading into a barracks mess hall. Restless children, young and old people, all wait to partake of their daily meal. The family dining room is replaced by a wood and tar paper structure, and the family unit becomes one extended line. A photo inset in the upper right of the watercolor shows the mural Takamura painted inside the mess hall.

16. Kango Takamura, *Hariuddo ni Ikiru* [Living in Hollywood] (Tampa, Florida, 1988), 127. Passage translated from Japanese by Eiichiro Azuma.

Takamura was an accomplished illustrator able to capture the distinct and individual personalities and experiences, and his work was not limited to humorous drawings. At Manzanar he documented the Manzanar Guayule Team which conducted research on the propagation and development of guayule, a rubber substitute. The Manzanar team included interned scientists, chemists, and agricultural specialists working under the direction of Robert Emerson of California Institute of Technology. Because access to rubber supplies was limited during the war, the Manzanar Guayule Team's research was important to the war effort. Takamura's watercolors follow the progress of the research team, from the growth of seedlings to experimentation in the sophisticated science lab.

An early watercolor painted on the evening of May 31, 1942 at Santa Fe, *At Evening Sketched This Beautiful Unusual Cloud Formation* (1942), is eerie in its prescience. Internees saw a mushroom cloud in the eastern sky. Takamura wrote, "We wondered whether these [clouds] might mean that we would be at peace."[17] Although he could not be sure, in later years Takamura believed the cloud formation was the result of nuclear testing in the New Mexico desert.

George Hoshida also used his drawing skills to document. Hoshida was born in Japan and immigrated to Hawaii at the age of five. He was a civic-minded man, active in the United Young Buddhists Association and judo organizations while working for the Hilo Electric Company. After the bombing of Pearl Harbor, Hoshida was arrested by the FBI because of his leadership in community organizations, in particular the Big Island Hongwanji Judo Association. Japanese Americans constituted a significant proportion of the total population of Hawaii, making mass evacuation economically and logistically impossible. However, Japanese Americans in Hawaii were not free from government suspicion and paranoia. Within the days following the attack on Pearl Harbor, "suspicious" Japanese Americans were rounded up. Others were singled out and forced to relocate when their farms, businesses, or homes were perceived to be in sensitive zones. The forced relocation was based solely on race; only those of Japanese descent were affected.

40.

17. *Ibid.*, 129.

Hoshida was one of seven to nine hundred Japanese Americans in Hawaii who were incarcerated in Justice Department internment camps.[18] He was first sent to Volcano Military Camp, also known as Kilauea Military Camp, and was later transferred to Sand Island Detention Center in Oahu. From Sand Island he began a long journey to the mainland, where he was interned at Lordsburg and Santa Fe before being reunited with his family, who left Hilo to join him at Jerome Relocation Center. More than one thousand women and children left Hawaii to join their husbands and fathers in mainland internment camps.[19]

Hoshida had been interested in art since childhood and he used his abilities to keep an almost daily record of his incarceration. He was fully aware of the importance of recording his experiences through his pen and ink drawings, and through the countless letters he sent to his wife and family. He drew on loose leaf binder paper that he had requested from his wife upon arrival at Kilauea and carefully compiled the drawings into binders. He docu-

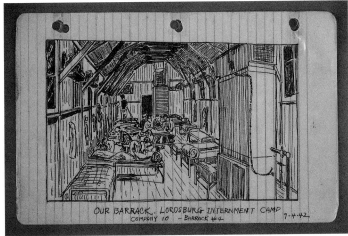

**George Hoshida
detail from
*American World
War II Concentra-
tion Camp
Sketches, 1942 -
1943***
**Loose leaf binder
with eighty-five
pages of drawings
and watercolors on
paper, 10" x 7.5' x
1.5"**
**Collection of
Sandra Takahata**

mented his surroundings and his daily activities. Interestingly, the tone of his sketches stands in sharp contrast to that of his written word. While his letters reveal despair, uncertainty, loneliness, and constant concern for his family, his sketches feel more positive. The drawings were a way to communicate with his pregnant wife and three daughters, including one who was severely disabled. Hoshida did not attempt to make any overt commentary on the internment, but he succeeded in providing a continuous and detailed account of images he saw and the people he knew.

18. Roland Kotani, *The Japanese in Hawaii: A Century of Struggle* (Honolulu: The Hawaii Hochi, Ltd., 1985), 80.
19. *Ibid.*, 85.

The internment experience was also shared by a few Caucasians. Estelle Ishigo was a white woman married to a Nisei. With incarceration, she chose to accompany her husband to the camps, first to Santa Anita and later to Heart Mountain. Ishigo's work is most powerful in its simple, yet stark contrast of human life against the physical and psychic boundaries imposed by incarceration. In *Boys With Kite* (1944) two children attempt to untangle their yellow kite from the throws of a barbed wire fence. The innocence of childhood, and by extension, of Japanese Americans, is caught within an unremitting barrier. Even attempts at recreation and normal activity within the confines of camp are stymied. Ishigo's direct, and uncompromising indictment of incarceration suggests that her status as a Caucasian granted her the confidence and freedom to create these strikingly forthright images.

Other artists created work in isolation, by choice or circumstance. Hideo Kobashigawa was one such artist. Born in Arizona in 1917, he moved to Okinawa with his family as a small child. He returned to the United States as a teenager. He worked as a gardener and took classes at Otis Art Institute in Los Angeles.

42.

Kobashigawa did not interact with the other artists interned in Manzanar. Yet he participated somewhat in the community life. Shortly after his arrival in Manzanar, he completed a mural in the block mess hall, and in the spring of 1942 he began a large wood block print project. He hoped to give a print of a panoramic view of Manzanar to every family interned for the cost of the paper. But the 1943 "loyalty" questionnaires halted this desire. In February 1942 the government required all people over seventeen years of age to sign what constituted an oath of loyalty. One question required internees to forsake former allegiance to the emperor of Japan and pledge allegiance to the United States. Another asked about the willingness to serve in the armed forces. The language was tricky. An affirmative answer implied forsaking former allegiance to Japan and left the Issei, who were forbidden by law to become citizens, without a country.

With Kobashigawa's "no-no" response to the loyalty questionnaires, he was transferred to Tule Lake in the spring of 1943. While Kobashigawa found inspiration in the natural beauty of Manzanar, Tule Lake had a completely opposite effect. The large mass of the dark mountain and the thick, mud-like application of paint in *Tule Lake* (1945) echo the depressing circumstances of Kobashigawa's transfer to camp and the possibility of forced deportation to Japan. But at Tule Lake, there were other artists who met informally to make art. Kobashigawa participated as did Taneyuki Dan Harada, who continued learning from the older artists at Tule Lake as he had started with George Hibi at Topaz.

The internment remained a key event in Kobashigawa's artistic life. After his release, he continued to work and rework images of the camps based on memory and imagination. In a large artist's book made in 1991, Kobashigawa compiled more than ninety drawings and watercolors from his incarceration at Manzanar and Tule Lake along with close to forty drawings and watercolors made in

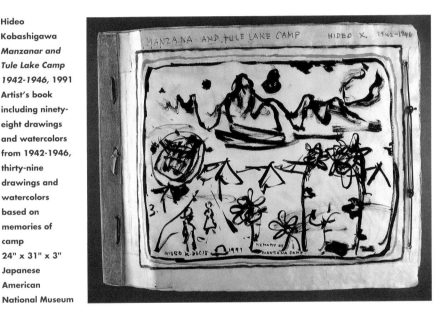

Hideo Kobashigawa *Manzanar and Tule Lake Camp 1942-1946*, 1991 Artist's book including ninety-eight drawings and watercolors from 1942-1946, thirty-nine drawings and watercolors based on memories of camp 24" x 31" x 3" Japanese American National Museum

1991 based on memories of the camps. The book reveals his working process and development of an idiosyncratic artistic style from 1941 to the present through his exploration of the impact of incarceration on his life.

But what was the impact of incarceration on the artistic lives of those interned? For many artists, the time during incarceration would provide the last opportunity to make art. Prewar racism, and the social and economic difficulties that faced the Issei would pale in comparison to the postwar milieu and the psychological scars left by incarceration. Like those of any traumatic and

disruptive incident, the internment's effects were manifested over the course of time. For George Matsusaburo Hibi, Kenjiro Nomura and Kamekichi Tokita, the wartime paintings were among their last, as they died shortly after being released. For others, like Sadayuki Uno and Tokio Ueyama, the postwar pressures of starting anew made the pursuit of art making impossible. Henry Sugimoto turned to the memories of specific incidents, and Hisako Hibi would change and grow as an artist until her death in 1991. The incarceration changed the lives of all those interned and by extension, the way they made art. Through the art they made in the camps, we can begin to learn more about the artistic output of a vital and prolific generation of Japanese American artists and start the long process of reclaiming their histories.

44.

BEHIND BARBED WIRE

Lane Ryo Hirabayashi and James A. Hirabayashi

BEHIND BARBED WIRE

Lane Ryo Hirabayashi and James A. Hirabayashi

On February 19, 1942, two months after the outbreak of war between the United States and Japan, President Franklin D. Roosevelt signed Executive Order 9066, which authorized the secretary of war and his military commanders to exclude persons from strategic military zones along the Pacific Coast, as well as the southern half of Arizona. Congress backed the executive order by passing a public law that subjected civilians who violated it to imprisonment and fines. The Western Defense Command under John L. DeWitt issued more than one hundred orders that applied exclusively to the more than 110,000 persons of Japanese ancestry in California, Washington, Oregon, and Arizona.

As a result, Japanese Americans were forced to abandon businesses, homes, farms, and their personal belongings. Under military guard they were first transported by trains and buses to a total of sixteen detention camps, euphemistically called "assembly centers," most of which were located in California. Crudely built shacks and horse stables served as mass housing for tens of thousands. In the summer of 1942 inmates of the detention camps were removed to concentration camps in the interior, in some of the most desolate parts of California, Arizona, Idaho, Wyoming, Colorado, Utah, and Arkansas.

What led to this unprecedented action on the part of the United States government? How did Japanese Americans respond? What were the consequences for a society in which freedom and equality are constitutionally guaranteed? To answer these questions, we must go back to the beginnings of Japanese immigration to America.

THE EARLY YEARS

In Portland where four Japanese had found jobs as trackmen at Astoria for the Southern Pacific Railroad . . .

one evening considerable numbers of whites broke in, holding hunting rifles in their hands,

and threatened the Japanese, "We'll kill you if you don't leave here within 30 minutes!" KAZUO ITO[1]

Tales of boundless economic opportunity lured the Issei, the immigrant generation, to the new land. On February 8, 1885, the ship *City of Tokio* arrived in Honolulu harbor with 944 immigrants on board. This was the beginning of officially sanctioned labor migration. From 1885 on, the Japanese immigrants came to America in increasing numbers mainly from prefectures along Japan's inland sea. By the time of the Immigration Act of 1924, which effectively barred further immigration, 200,000 Issei had settled in Hawaii and 180,000 in the continental United States.[2] Additionally, some Issei from Hawaii migrated to the mainland. Initially most of the immigrants were sojourners who intended to return to Japan with their "fortunes." After their arrival the Issei worked hard as laborers in the fields, factories, forests, cities, and on the seas. They made vital contributions to the plantation economy in Hawaii, and to developing the western United States.

Although the Issei were reputed to be good workers, they were not docile under abusive conditions. The history of Issei militancy dates back to the beginning of their labor contracts in Hawaii. Plantation workers rebelled under unbearable conditions. The Issei participated in two large organized strikes, in Hawaii in 1909 and 1920. On the mainland the Issei struck against the sugar beet owners in 1903. They were not alone in their protests. In the Oxnard, California 1903 strike and the Hawaii 1920 strike the Issei formed coalitions with Mexican and Filipino workers.

48.

1. Kazuo Ito, *Issei: A History of Japanese Immigrants in North America* (Seattle, 1974), 91.
2. Ronald Takaki, *Strangers From a Different Shore: A History of Asian Americans* (Boston: Little Brown and Co., 1989), 45.

Immigrant records —

Now and then a bloody page

indicates the pain SHUNYO[3]

Although the Japanese made up only a fraction of the total population on the United States mainland, prejudice against them came from many quarters during the first decade of the twentieth century. Labor unions, followed by politicians, scholars, and political and civic organizations, agitated against them. Exclusion leagues were formed to lobby against further Japanese immigration. In October 1906 the San Francisco School Board expelled all Japanese American children from public schools and ordered them to join Chinese American students in a segregated school. Pressure by exclusionists led President Theodore Roosevelt to negotiate the Gentlemen's Agreement of 1908 with the Japanese government: in return for Japan's voluntary restriction of emigration of laborers, Roosevelt promised to protect the rights of Japanese nationals in America.

49.

The Gentlemen's Agreement stopped labor migration but allowed Issei to bring their wives and family members to America. The Japanese established families and communities. Exclusionists, reacting to this trend, agitated for a change in the laws. Banned from becoming naturalized citizens, the first generation Japanese became targets for further restrictions. The California Alien Land Law of 1913 forbade all "aliens ineligible to U.S. citizenship" to buy property or lease it for a period of more than three years. A revision of the law in 1920 made it illegal for the Issei even to lease land. Though they were not citizens, some of the Issei boldly went to court to challenge these discriminatory practices. Not surprisingly, these challenges were largely unsuccessful. In 1920, the Japanese government agreed to stop issuing visas to Japanese women. Abandoned by the Japanese government, the Issei resolved to fight on their own.

3. Shunyo, in Ito, *Issei*, 105.

The Issei made repeated attempts to gain naturalized citizenship. In 1922 the Japanese Association found an ideal case in Takao Ozawa, a highly Americanized Issei, to challenge the Naturalization Act of 1790 which limited naturalization to free and "white" immigrants, thus making all Asians "aliens ineligible to citizenship." The United States Supreme Court rejected Ozawa's appeal, a bitter defeat that ended Issei hopes of becoming American citizens.

The Immigration Act of 1924 halted immigration by the Japanese and all other Asians. Exclusionary laws discriminating against Asians were not repealed until the latter part of this century.

BUILDING COMMUNITIES

50.

Issei's common past—

Gritting of one's teeth

Against exclusion KOTOE [4]

Despite the hostile society which they encountered, Japanese Americans established communities in urban centers along the West Coast, forming links with farming communities. The Issei also engaged in wholesale-retail trade in vegetables, fruits, fish and flowers, and established independent businesses to serve their communities. They encouraged harmony and mutual aid within family and community. They promoted and taught their children, the Nisei, values such as mutual responsibility, respect for elders, and the value of hard work. Denied naturalization rights and land ownership, the Issei invested their hopes, dreams, and desires in the next generation. Issei immigrant parents promoted education and the Nisei worked hard in school. Nisei attempts to assimilate into the middle class society, however, were often stymied. Many college graduates could find work only on their parents' farms and fruit stands. The Nisei were suspended between two worlds.

4. Kotoe, in Ito, *Issei*, 105.

By the beginning of World War II the Japanese American community could no longer be considered a sojourner one, but had become a vital and dynamic community rooted in America. Despite their change of status from sojourners to settlers, however, Japanese Americans were still suspect in times of national crisis. The Federal Bureau of Investigation and army and naval intelligence began watching Japanese Americans in the early 1930s. Agents compiled records on community leaders and on those who appeared to have familial, religious, economic, or political ties to Japan. In Hawaii the military, aided by the FBI, began collecting intelligence reports on the Japanese as early as the 1920s.

THE OUTBREAK OF WAR

I bid farewell

to the faces of my sleeping children

As I am taken prisoner

Into the cold night rain M. OZAKI[5]

In 1941 there were 158,000 people of Japanese ancestry living in Hawaii, 37 percent of the population. Ninety-four thousand lived in California, but they constituted only 1 percent of the population.[6] There were 25,000 in the states of Washington and Oregon, with a total of 285,115 in the 1940 U.S. Census.[7] On December 8, 1941, the day after the attack on Pearl Harbor, 736 Issei were arrested by the FBI. Within a week, more than two thousand Issei on the U.S. mainland and Hawaii deemed to be "suspicious" on the basis of the FBI's secret intelligence were detained in camps operated by the Immigration and Naturalization Service.[8] In Hawaii martial law was declared, and those considered "subversive" were interned at Sand Island and Honouliuli.

51.

5. M. Ozaki, in Jiro Nakano and Kay Nakano, editors, *Poets Behind Barbed Wire* (Honolulu: Bamboo Press, 1984), 86-87.
6. Takaki, *Strangers*, 379.
7. David O'Brien and Stephen Fugita, *The Japanese American Experience* (Bloomington: Indiana University Press, 1991), 137.
8. Sucheng Chan, *Asian Americans: An Interpretive History* (Boston: Twayne Publishers, 1991), 123.

Authorized by President Roosevelt's Executive Order 9066, General DeWitt established more than one hundred prohibited zones within the West Coast region and proclaimed the entire West Coast as well as southern Arizona as a restricted zone in which all Japanese Americans had to abide by travel restrictions and curfew laws. A key member of the Western Defense Command, Col. Karl Bendetsen stated: "I am determined that if they have one drop of Japanese blood in them, they must go to camp." The public policy of mass incarceration was directed solely at persons of Japanese descent, despite the fact that America was also at war with Italy and Germany. Moreover, Japanese Hawaiians were never subjected to mass incarceration, although Hawaii was more susceptible to invasion.

The Supreme Court, charged with the duty of protecting citizenship rights, succumbed to public pressure. Seven of the nine justices were appointees of President Roosevelt. Justice Frank Murphy acknowledged, "Today is the first time, so far as I am aware, that we have sustained a substantial restriction of the personal liberty of citizens of the United States based upon the accident of race or ancestry."

52.

In late February of 1942, all Japanese Americans were removed from Terminal Island, California, by the Navy. A month later, to gain experience in the logistics of removal, the army moved Japanese Americans off Bainbridge Island, Washington. Sixteen temporary quarters were set up at fairgrounds, racetracks, and other facilities in Puyallup, Washington; Portland, Oregon; Marysville, Sacramento, Tanforan, Stockton, Turlock, Salinas, Merced, Pinedale, Fresno, Tulare, Santa Anita, Manzanar, and Pomona, California; and Mayer, Arizona. Meanwhile, permanent barrack-style quarters were being established in Tule Lake and Manzanar, California; Poston and Gila River, Arizona; Minidoka, Idaho; Topaz, Utah; Heart Mountain, Wyoming; Amache, Colorado; and Jerome and Rohwer, Arkansas. A civilian agency, the War Relocation Authority (WRA), was established to administer these camps. Euphemistically called relocation centers by the government, President Franklin D. Roosevelt referred to them as concentration camps. Most of the internees in the Immigration and Naturalization Service Centers were Issei, joined by a few

thousand immigrants from Mexico and Latin America. In total, the internees in all of the camps numbered over 120,000. Betrayed by their government, Japanese Americans became the victims of racism and wartime hysteria. Under the false premise of military necessity, Japanese Americans were singled out, uprooted from their homes, and confined in the internment centers. Not a single case of espionage or sabotage was ever attributed to the Japanese Americans.

BEHIND BARBED WIRE

We lived one family to a unit, four units to a barrack, with knotty walls separating us from our neighbors. There was little privacy. Furtive love affairs were conducted in the shadows of barracks and in empty officer rooms. Family quarrels were stifled and swallowed. The latrines were the worst: rows of toilets back to back, one long trough for washing, a shower room with six shower heads. The modest met each other coming and going in the early hours of the morning. WAKAKO YAMAUCHI [9]

53.

What was life like in the camps? The ten War Relocation Authority (WRA) camps were located in forbidding areas that were too hot during the summers and both muddy and freezing during the winters. Each block of a dozen or more barracks had a central mess hall, laundry, toilets, and showers. Food costs were limited to forty-five cents a day per person but soon a large part of the food supply was grown in the camp fields maintained by the internees. At Manzanar, inmates cultivated three hundred acres within four months. They constructed an irrigation system, planted corn, cucumbers, tomatoes, radishes, and melons, and revived some of the orchards nearby. Soon they were shipping surplus crops to the other camps.

The internees organized and operated cooperatives. All necessary jobs—such as office workers, barbers, garbage collectors, firemen, doctors, janitors, and farmers—were quickly allocated. Wages were low, ranging from twelve dollars per month for menial laborers

9. *The Christian Science Monitor*, November 8, 1988.

to nineteen dollars per month for professionals such as doctors. The average wage was sixteen dollars per month. The work setting created anomalous situations. Journeyman doctors, for example, worked under less experienced Caucasian counterparts earning much more pay. Successful farmers were reduced to manual labor on the camp farms. For artists, ironically, incarceration brought some advantages. It provided them with compelling subject matter and the time to paint. Art schools were quickly organized and creative activities flourished.

The War Relocation Authority, as a means to control the internees, imposed a paternalistic self-governing structure which favored the second generation, which had not yet assumed leadership in the prewar communities. Camp administrators banned the use of Japanese in camp meetings and placed the Americanized Nisei into positions of responsibility, widening the generation gap.

54.

Resistance in the WRA camps began within a few months. It took the form of strikes, riots, and beatings, and even the assassination of those who were suspected of informing to the authorities. The internees were factionalized by differing strategies of whether to cooperate with or resist the WRA authorities. In Poston the conflict escalated from beatings to arrests and a major strike. In Manzanar soldiers killed two internees when protests escalated into a major confrontation. Other forms of resistance tactics included the posting of anonymous flyers that protested injustices, work slowdowns, hunger strikes, stealing, defiance through gambling, the distillation of spirits, and other forbidden acts. And, most important, messages of protest appeared in poetry and art.

The circumstances under which the internees lived led to conflict. The army's decision to induct Nisei into the 442nd, an all-Japanese American combat team only exacerbated the situation. To separate the loyal from the disloyal, the army instituted a questionnaire. Male citizens were asked: "Are you willing to serve in the armed forces of the United States on combat duty,

wherever ordered?" and "Will you swear unqualified allegiance to the United States of America and faithfully defend the United States from any or all attacks by foreign or domestic forces, and forswear any form of allegiance or obedience to the Japanese emperor or any other foreign government, power or organization?" This brought mixed responses from the internees.

After the draft was reinstituted, resisters in the Heart Mountain camp organized the Fair Play Committee, maintaining that they should uphold American democracy at home and resist the denial of their constitutional rights. The three leaders of this movement were sent to the Tule Lake camp which became a segregation center for the "disloyals." Subsequently, sixty-three men who refused induction were given a mass trial and sentenced to federal prisons for three years. A total of 267 men were convicted of draft evasion and sent to prison.

Under these circumstances, it is amazing that some one thousand young men in the internment camps volunteered for service in the armed forces of the United States. About eight hundred of them were accepted. The Japanese American Citizen's League (JACL), founded in 1930 by a group of Americanized Nisei, lobbied for the formation of an all-Japanese American unit that would enable them to prove their loyalty. The league urged the Nisei to cooperate with the army when the draft was reopened. It is ironic that the Nisei felt compelled to volunteer to serve in segregated units "to defend democracy" while their families remained incarcerated.

55.

When Tule Lake Camp became a segregation center, many of those answering yes to both questions on the loyalty questionnaire were moved to other camps or left the camps for the Midwest and the East. The Nationality Act of 1940 was amended, making it possible for the internees to renounce their U.S. citizenship and to take the ultimate step of "repatriation" to Japan. Yet, fewer than 5 percent of the internees left the camps to return to Japan at the end of the war.

The camp communities exhibited resilience, persistence, and strength. The internees established schools, hospitals, and police and fire departments. Churches flourished, with their multitude of activities. The internees joined singing, dancing, flower arrangement, doll making, wood carving, bonsai, and poetry clubs. Adult education included classes in dress making, design, English, psychology, photography, journalism, and technical areas. For children and teenagers, there were various activities during school classes and after hours: clubs, socials, dances, and sports such as baseball, football, and basketball.

POSTWAR: REDRESS AND REPARATIONS

Japanese Americans began to leave the camps and to reintegrate into the larger society as early as 1943. In the postwar period, the Nisei were able to make great strides in fields that had previously been barred to their parents and themselves, such as civil service, education, and law. Their reentry into society provided the impetus for re-asserting the rights which the U.S. government had abrogated during the war. The campaign for redress and reparations officially began in the 1970s when Japanese Americans called upon the United States government to acknowledge a wrong, to correct the record, and to require that the Constitution of the United States and the Bill of Rights be applied equally to all. The Commission on Wartime Relocation and Internment of Civilians (CWRIC) was established by Congress in 1980 to study the internment of Japanese Americans. The commission was charged to review the facts and circumstances surrounding Executive Order 9066, issued February 19, 1942, and the impact of such an order on American citizens and permanent resident aliens. The commission's charge also included the review of directives of the United States military forces that led to the relocation, and in some cases, detention of American citizens including Aleut civilians and permanent resident aliens of the Aleutian and Pribilof islands, and to recommend appropriate remedies.

56.

The hearings of the Commission on Wartime Relocation and Internment of Civilians began in Washington, D.C., on July 14, 1981, and continued throughout the summer and fall in Los Angeles, San Francisco, Seattle, the Aleutian and Pribilof islands, Chicago, and New York. At these hearings Japanese Americans presented hundreds of written and oral testimonies on the Japanese American concentration camps. On August 10, 1988, House Resolution 442 was signed into law by President Reagan. It provided for individual payments of twenty thousand dollars to each surviving Japanese American internee and a 1.25 billion dollar educational fund, among other provisions.

Redress and reparations, however, are not the end of the internment story. There are still stories waiting to be told. Let all the voices be heard: the Issei who are still alive, the Nisei, Kibei, and Sansei, the resisters, veterans, and renunciants. We need all of their voices to discover and understand fully the story of the Japanese American internment.

57.

The internment is a story of the reaffirmation of an ethnic culture in our multicultural society. It is a story of oppression, resistance, and the ability of a people to challenge their circumstances. It is a story captured by artists whose canvases reflect the emotional impact of removal and imprisonment, feelings of shock, dismay, and sorrow. In the work of Japanese American artists who were interned, we discover panoramic views of camp and wilderness, and feel the harsh wind, sand, and heat that were part of the environment. The artists also provide us with intimate views of day-to-day life: meals in the mess halls, work and leisure—all through periods of outrage, terror, and joy. Life did go on, despite the barbed-wire enclosures.

Yes, it's right that we're here

to see first hand where

18,000 of us lived

for three years or more

to see again

the barbed wire fence

the guard towers, the MPs

the machine guns, bayonets

and tanks, the barracks

the messhalls, the shower rooms

58. *and latrines.*

I wish I could share

the feelings I have now

with the Issei and Nisei

they who lived here

they who do not speak of it

who pass it off

as a good time experience.

Whatever we did here

the commitments we made

loyal or disloyal

compliance or resistance

yes or no

it was right!

Because the young people

make it so because they seek the history

from those of us who lived it.

HIROSHI KASHIWAGI [10]

James A. Hirabayashi, Ph.D., is chief curator of the Japanese American National Museum.
Lane Ryo Hirabayashi, Ph.D., is associate professor of anthropology and the Center for Studies of Ethnicity and Race in America, University of Colorado at Boulder.

10. Hiroshi Kashiwagi, "A Meeting at Tule Lake," in *Kinenhi: Reflections on Tule Lake* (San Francisco: Tule Lake Committee, 1980).

SELECTED BIBLIOGRAPHY

Commission on the Wartime Relocation and Internment of Civilians. *Personal Justice Denied.* Washington, D.C.: U.S. Government Printing Office, 1982.

Daniels, Roger. *The Decision to Relocate the Japanese Americans.* Philadelphia: Lippincott, 1975.

_____ . *Concentration Camps, North America: Japanese in the United States and Canada During World War Two.* Melbourne: Kreiger, 1981.

Drinnon, Richard. *Keeper of Concentration Camps: Dillon Myer and American Racism.* Berkeley, Los Angeles, and London: University of California Press, 1987.

Hohri, William Minoru. *Repairing America: An Account of the Movement for Japanese American Redress.* Pullman, Washington: State University of Washington Press, 1988.

Ichioka, Yuji. *The Issei: The World of the First Generation Japanese Immigrants, 1885-1924.* New York: Free Press, 1988.

_____ . *Views From Within: The Japanese American Evacuation and Resettlement Study.* Los Angeles: Asian American Studies Center, University of California, 1989.

Irons, Peter. *Justice at War: The Story of the Japanese American Internment Cases.* New York: Oxford University Press, 1983.

Niiya, Brian. *Japanese Americans During World War II: A Selected Annotated Bibliography of Materials Available at UCLA.* Los Angeles: Asian American Studies Center, University of California, 1992.

Tanaka, Chester. *Go for Broke: A Pictorial History of the Japanese American 100th Infantry Battalion and the 442nd Regimental Combat Team.* Richmond, California: Go for Broke, 1982.

Tateishi, John. *And Justice For All: An Oral History of the Japanese American Detention Camps.* New York: Random House, 1982.

Weglyn, Michi. *Years of Infamy: The Untold Story of America's Concentration Camps.* New York: William Morrow, 1976.

59.

INTERNMENT CHRONOLOGY

Brian Niiya

1941

Dec. 7 The attack on Pearl Harbor.

Dec. 7 Beginning on the evening of December 7, Japanese Americans who were perceived by authorities to be dangerous were rounded up. By 6:30 A.M. the next morning, some 736 were in custody; within forty-eight hours, the number had risen to 1,291. Guilty of no crime, these people were mostly Issei men who held positions of influence in the Japanese American community—Buddhist priests, Japanese Language School instructors, Japanese Association officials, and others. Most of these men spent the war years in enemy alien internment camps administered by the Justice Department.

1942

Feb. 19 Executive Order 9066 was issued by President Franklin D. Roosevelt. This sweeping resolution authorized military authorities to remove individuals residing in the western states for reasons of "military neccessity." E.O. 9066 provided the legal authority behind the mass removal of Japanese Americans from the West Coast.

Feb. 25 Japanese American residents of Terminal Island, a thriving Japanese American community near the Los Angeles Harbor, were informed by the navy that they had forty-eight hours to leave. They represented the first group of Japanese Americans to be removed en masse.

Mar. 2 John L. DeWitt, head of the Western Defense Command, issued public proclamation no. 1 which created military areas nos. 1 and 2. Military area no. 1 included the western portions of California, Oregon and Washington, and part of Arizona, while military area no. 2 included the rest of these states. The proclamation also indicated that people would be excluded from military area no. 1 and encouraged Japanese Americans to leave voluntarily. For various reasons, voluntary resettlement was doomed to failure and was effectively called off on March 27 after fewer than five thousand people (out of over 110,000) had left the area.

Mar. 18 The War Relocation Authority was created.

60.

Mar. 24 The first of 108 "Civilian Exclusion Order" was issued, informing Japanese Americans of Bainbridge Island, Washington that they had to leave. For the rest of the spring, through the summer and into the fall, Japanese Americans up and down the West Coast were removed neighborhood by neighborhood through these "exclusion orders." Most Japanese Americans were taken to a local "assembly center," or temporary detention camp, upon removal.

Mar. 28 Minoru Yasui walked into a Portland, Oregon police station at 11:20 P.M. to present himself for arrest to test the constitutionality of the curfew orders in court. His case, along with those of fellow dissenters Gordon Hirabayashi and Fred Korematsu, reached the U.S. Supreme Court.

May 8 The first "volunteers" arrived at Poston, Arizona, one of ten "relocation centers" which housed Japanese Americans during the war years. Through the rest of the summer, Japanese Americans were transferred from the "assembly centers" to Manzanar and Tule Lake, California; Amache, Colorado; Minidoka, Idaho; Topaz, Utah; Heart Mountain, Wyoming, Rohwer and Jerome, Arkansas; and Gila River and Poston, Arizona.

May 29 The National Japanese American Student Relocation Council was established in Philadelphia. With the help of this organization, some 4,300 Nisei left the camps to attend college or work in the East or Midwest. A steady stream of the "loyal" continued to leave the camps for the duration of the war.

Nov. 14 An attack on a perceived informer at Poston and the subsequent arrest of two popular inmates for the crime mushroomed into a massive strike. A similar uprising took place at Manzanar one month later.

1943

Feb. The so-called "loyalty questionnaires" were circulated at the ten camps. They served the dual purpose of registration for potential military service and for identifying the disloyal and the loyal in order to segregate the former and expedite the release of the latter. The poor design of the questionnaire led to uncertainty and unrest among the inmates as many refused to answer the questions or give conditional answers.

Feb. 1 The 442nd Regimental Combat Team, a segregated all-Nisei unit, was activated. A call for volunteers yielded vastly different results in Hawaii than on the mainland: some ten thousand Hawaiian Nisei volunteered within days, while only 1,256 mainland Nisei came forward from the camps.

Sept. 2 After nearly a year and a half of training, the 100th Infantry Battalion, an all-Nisei unit from Hawaii, finally landed in Oran, North Africa. They were joined by the 442nd in June 1944. Together, they went on to compile a sterling war record, suffering high casualty and low desertion rates, and winning numerous unit and individual citations.

Fall Based on responses to the loyalty questions, the loyal and disloyal were segregated. The "disloyal" from the various camps were sent to Tule Lake, which became a "segregation center," while the "loyal" from Tule Lake were sent to other camps.

Nov. 4 A mass uprising at Tule Lake capped a month of increasing tensions since segregation.

1944

Jan. 14 Nisei eligibility for the military draft was reinstated.

Jan. 26 The Heart Mountain Fair Play Committee (FPC), destined to become the only organized resistance to the military draft, was formed at a rally. Made up of loyal Nisei, the FPC members refused to report for draft physicals unless they and their families were granted their civil rights.

Oct. The 442nd RCT rescued the "lost battalion," a unit made up of Texans, in the forests of France. They suffered eight hundred casualties to rescue 211 men.

Dec. 17 The announcement that Tule Lake would be closed within a year led to mass hysteria at that camp. In the charged atmosphere of the next six months, 5,589 American citizens renounced their citizenship. Though some regained it after protracted legal battles, many returned to a Japan they had never known.

Dec. 18 The United States Supreme Court upheld Fred Korematsu's conviction of remaining in a military area contrary to an exclusion order. This decision effectively upholds the constitutionality of the mass removal of Japanese Americans from the West Coast. It has never been overturned.

62.

1945

Jan. The Hood River Oregon American Legion Post had the names of sixteen Nisei servicemen stricken from its honor role. The names were restored after the incident received national publicity.

Jan. 2 The ban on resettlement on the West Coast was lifted and a few cautious families began to return home. In the next six months, some thirty terrorist incidents targeting returning Japanese Americans took place, including fire bombings, shootings, and vandalism.

Aug. 14 The surrender of Japan.

1946

Mar. 20 Tule Lake closed. In the month prior to the closing, some five thousand inmates had to be moved, many of whom were elderly, impoverished, or mentally ill who had no place to go. Of the 554 persons left here at the beginning of the day, 450 were moved to Crystal City, 60 were released, and rest were relocated.

1947

Dec. The last Justice Department internment camp, Crystal City, closed.

POSTON, ARIZONA: A PERSONAL MEMORY

Wakako Yamauchi

POSTON, ARIZONA: A PERSONAL MEMORY

Wakako Yamauchi

Fifty years—half a century ago. We are speaking of another time, another life. We are returning to that era of war, divided loyalties, betrayal, and incarceration. Many of us have already gone, some in fading notoriety, some with trauma and conflicts unresolved.

If the median age of Japanese Americans in 1942 was seventeen, then my contemporaries and I were the average Japanese Americans of the time. We were seniors in high school. In another semester, we would graduate. And soon we would face grave situations and make important decisions.

Excluded from mainstream American society, we were more Japanese than American. We had watched our parents struggle through and survive the Great Depression; our thinking was narrow, our ambitions modest, and we were politically and socially naive. We separated the politics of nations from ourselves, even though they were inseparable from our parents' lives: the Alien Land Law, exclusion from citizenship, job discrimination. Although these truths appeared everywhere everyday, most of us believed our history books—America the land of the free, of Horatio Algers, the melting pot of the world.

War was raging in Europe. Every month there was another scare of war with Japan. The Draft faced our young men ready to graduate. College was an option. One could go to a university, become a doctor or lawyer or an accountant and serve the Japanese community. One could be an engineer and sell fruit in a roadside stand, or an electrician and fix toasters and radios, or a poet or artist and tend a nursery or trim lawns and hedges for wealthy whites. One could work a store or an office or farm a few acres like his father before him and wait to be inducted in the army. It was for men, a time to put childhood behind.

Being a girl was easier. For a long time I looked forward to falling in love, preferably to a dashing Robin Hood type, to a marriage that held no clue to reality—the cooking, cleaning, and budgeting part—to children who didn't soil diapers, and to a pink stucco house. Maybe.

But it was plenty to look forward to. Didn't the movies tell us so? Wasn't that the promise of the American dream? It was far more than our parents had or dreamed of having.

My mother left her native Japan and yearned for it forever after. She spent her productive years on a patch of leased land, moving every two years, seeding, harvesting, eking out a frugal living, watching her children drift away, grow more alien as the years slipped by. My father was trapped in the same pattern. In addition, he tried valiantly to hold on to his self respect, his image as man, provider, and protector.

66.

It was a narrow world we average Japanese Americans were born into, but like setting a microscope on a drop of water, there was teeming life beyond the naked eye.

From an early age I was aware of a vastly different world outside our farm. My father bought a twenty volume set of *The Book of Knowledge* and I poured over drawings of prehistory, reproductions of famous paintings, and illustrations of classic stories and poems. There were stiff portraits of important people and their important inventions. Among them was Dr. Noguchi who my mother said conquered yellow fever in the tropics. I don't know if this is true, but I had to accept her word because I couldn't read, but I never forgot it because I knew then, it was possible for Japanese to be in *The Book of Knowledge*. I felt proud.

The paintings fascinated me. There were swaggering portraits of a privileged class, of satin, jewels, buckled shoes, grand capes, and sweeping feathers. I was a kid peering through a candy store window.

But it was the black and white reproductions of Corot that moved me the most—the distant landscapes of peasants tending their animals in a glade, the chill of dusk in the air, the quiet sense that life went on before and will go on long after I am gone. It was the power of art to transport, to stir memories transcending experience. Here beyond the painting, the sky turns dark, supper steams over an open fire, and love awaits. I would be a painter when I grew up.

But let us now praise the resilience of youth and the hope that springs eternal and other timeless clichés. We were the America of the melting pot. In spite of the evidence, we did not doubt our country and the principles of democracy we read so much about. Lessons on slavery, greed, and chicanery were yet to come. And suddenly with the attack on Pearl Harbor, we were no longer Americans.

Who can forget what he or she was doing on that day?

I had gone to see Sergeant York at the Oceanside Theatre (we'd moved to Oceanside by then) and I'd spent almost two hours watching an All-American nobody become a hero shooting Germans the way he shot wild turkeys in the Tennessee hills. I came home full of rah-rah. My mother met me in the yard. She whispered, "America is at war with Japan." Her face was white; my heart sank for her. At that time I didn't dream of the implications. So on Sunday, December 7, we became the enemy.

We average Japanese Americans of seventeen years were powerless to stop what followed. Many of our fathers and community leaders were whisked away to detention camps and our homes were raided systematically. Some people advocated voluntary evacuation. "Let's be good citizens and show our loyalty by leaving voluntarily." Our self-hate and guilt were enormous.

Then with Executive Order 9066, we were forced to cram our lives into two suitcases and leave our homes. There was a small group who urged us to "fight to the last ditch." They said maybe some of us would die, but the world would then know we accept nothing less than full citizenship rights. The American Way.

But who wants to die? The idea did not take hold and we went on to the camps.

There were lines for everything: for mail, shots, at the pharmacy and clinic, at the mess halls. There were lines for toilets, showers, and laundry tubs. Everything was communal. No secret was safe. Every cough and quarrel was heard in the next barrack. Only the trauma of betrayal continued silently.

But in the spirit of *shikataganai* or "making the best of it," we bounced back. We formed softball teams and played intramural games. We produced talent shows. We set up libraries, beauty shops, cooperatives, flower and sewing classes, art and drama departments, dug swimming holes and so on, and boy scouts continued to march with Old Glory fluttering high.

68.

We published mimeographed bulletins. Ours was called *The Poston Chronicle*.

Four of us worked as artists at the *Chronicle*. We were young inexperienced kids cutting mastheads, lettering, and sometimes drawing caricatures and cartoons. Only one of us was good at it so he did most of the work. This was such an embarrassment to me, I took a course in cartoon drawing at the Poston Art Department.

Howard Kakudo was the instructor. Howard had worked at Disney's for two years on Pinnochio's Blue Fairy. He also drew beautiful pastels of movie stars for theatre displays. He was a professional artist—a rare breed. He was good-natured and extremely handsome; maybe someone's Robin Hood but not mine because he was older, but more important, the women who flocked to his classes were beautiful and sophisticated (though their motives blatant) and I was only a tumbleweed.

Other staff members were Frank Kadowaki, a quiet married man, and an intense fellow named Larry who was aggressively com-mitted to steering us to non-representational art. Still stuck in "real" and "pretty," most of us were intolerant of his ideas; his pushiness turned us off. He was, in today's jargon, not "cool."

Mysterious, half-Japanese Isamu Noguchi was already an acclaimed artist. He tramped the desert collecting ironwood and in his pith helmet, high-top shoes, and dusty denims, he sometimes dropped by to see Howard. Or maybe to study the array of pretty women. They said his father was famous and I was sure he was the son of Dr. Noguchi of *The Book of Knowledge* but my friend Hisaye said not so. Howard said Noguchi was making masks with the ironwood, and indeed, the front of his barrack was covered with huge fearsome African masks. Much later, Howard told me Noguchi took them all to New York and sold them for thousands of dollars.

Maybe he was getting rid of memories of Poston. Rumors of his unceremonious exit from camp were persistent. An irate husband, they said. Many years later I went to Noguchi's lecture at UCLA and among the slides was one he called Poston. Did I see a small breast in the gentle rise at the base? He clicked it by so fast, I couldn't be sure.

69.

My friend Hisaye Yamamoto covered the art and drama departments for the *Chronicle*. Since then she's become an internationally respected short story writer, but she put up with me (as she does now), a lonely depressed adolescent, and she let me hang out with her. Through Hisaye, I learned about other Nisei writers and artists who were even then recording their feelings about the "experience." I didn't find them myself.

On the covers of *Trek*, we saw Mine Okubo's claustrophobic look of camp life and the make-do spunk of people whose holiday spirit would not be suppressed. She endured the wind and dust and isolation and tramped through Topaz putting it all down. There were stories of the identity problem before it was called the "identity problem." It was an education.

Years later, I learned of other camp artists, of the tragic life of Estelle Ishigo, the loneliness calling out from her drawings. One painting by Henry Sugimoto brought back the smell and sounds of camp—the season: edge of winter, frost on the breath, a dying pipe, hammering in the distance, warmth under the pea coat. It was painted on mattress material and the woven blue stripes of the ticking brought it all back home.

When I was a grown woman I sent my only child to school and returned to painting. In the adult education class, I met three Issei. One was Mrs. Yamagishi, at that time already ninety-four. Somehow, indelibly stamped in her data bank was a picture of her childhood that found its way into every painting she made. The tired white models who sat for us always had cherry blossom cheeks and shining eyes. Pink and red collided with green and turquoise. Unsullied by pontification, the paintings sang with child-like joy.

Mrs. Hosoume, then in her eighties, was an accomplished painter. After camp she studied with Taro Yashima. In her painting of a lantern, one can sense a person who, in the age of electronics, clings to a rusty lantern that once lit her nights. It speaks of a time gone—a gossamer memory remaining.

70.

Mr. Abiko was in his late eighties. When I met him, he was working with geometric shapes and basic colors—a little like Mondrian. His paintings were beyond me, but once in a while I'd feel a certain fire. One day I persuaded him to show me his collection. Among the abstracts I found a camp painting carefully wrapped in tissue paper. It was a piece of Mr. Abiko's history—the years of his life in a barrack home, the flowers he'd potted set on the splintered porch. He had caught the morning light that slipped past another barrack and lit the flowers. "I will never paint like that again," he said. I wanted to cry.

Now Mr. Abiko's sky has turned dark. Mrs. Yamagishi's too. Mrs. Hosoume is ninety-nine. For them, supper steams over an open fire and love waits.

Well, they say all life is terminal. But each of us wants to leave a stone that says, "I have been here." An artist suspends a moment of his inner life—a fleeting moment of passion and longing in life and puts it on a canvas for us.

Wakako Yamauchi is a Los Angeles playwright and writer. Her plays include: And the Soul Shall Dance (1977), 12-1-A (1982), Music Lessons (1983), and The Chairman's Wife (1990).

COLOR PLATES

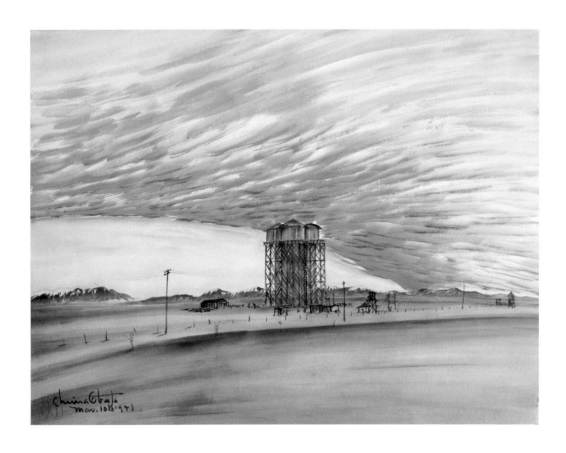

plate one

Chiura Obata
Sunset, Water Tower, Topaz
1943
Watercolor on paper, 15.5" x 20.5"
Estate of Chiura Obata

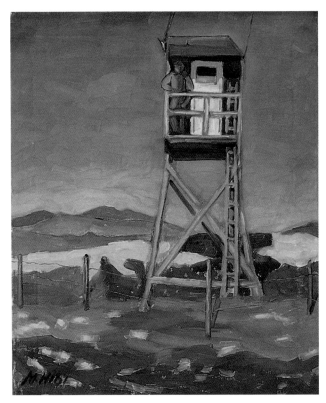

74.

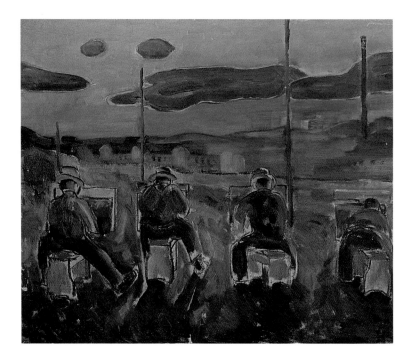

p l a t e s t w o & t h r e e

George Matsusaburo Hibi
Watch Tower (left)
Men Painting, Sunset, Topaz (right)
c. 1944
Oil on canvas, 22" x 18" and 20" x 24"
Department of Special Collections, University Research Library, UCLA

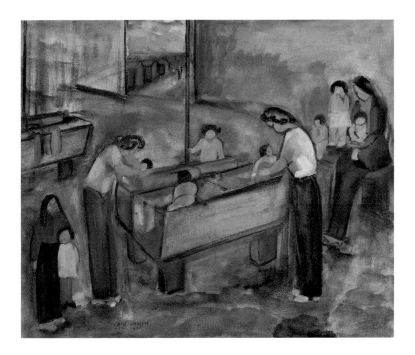

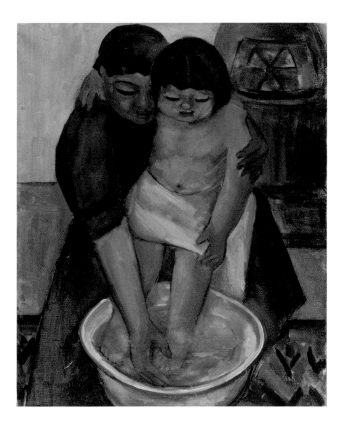

75.

p l a t e s f o u r & f i v e

Hisako Hibi
Laundry Room (left)
Homage to Mary Cassatt (right)
1943
Oil on canvas, 20" x 24" and 24" x 20"
Estate of Hisako Hibi

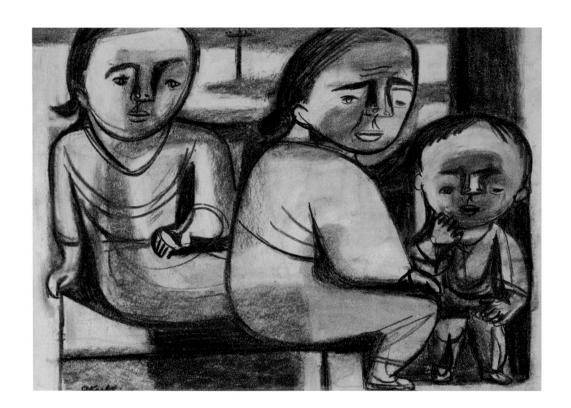

76.

plate six

Mine Okubo
Mother and Children - People Were in Shock
1943
Charcoal on paper, 14" x 20"
Collection of the artist

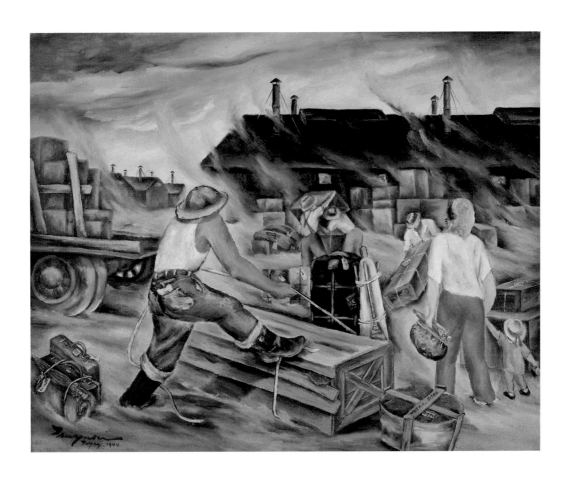

plate seven

Byron Takashi Tsuzuki
Forced Removal, Act. II
1944
Oil on canvas, 24" x 30"
Collection of August and Kitty Nakagawa

78.

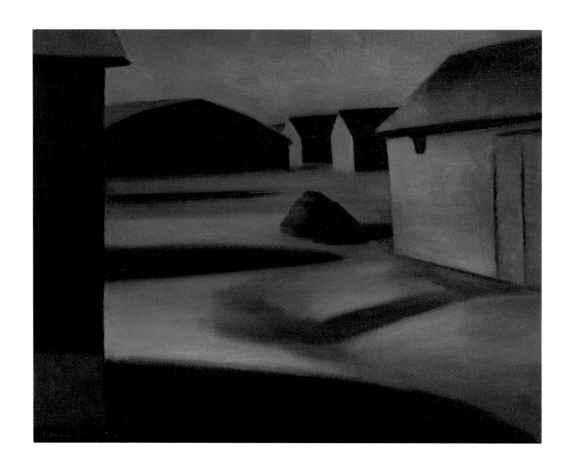

plate eight

Taneyuki Dan Harada
Barracks
1944
Oil on canvas, 22" x 28"
The Michael Brown Collection

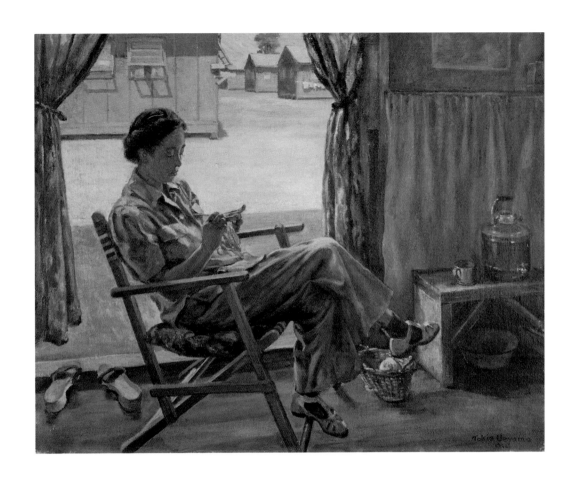

79.

plate nine

Tokio Ueyama
The Evacuee
1942
Oil on canvas, 24" x 30.25"
Gift of Kayoko Tsukada
Japanese American National Museum

80.

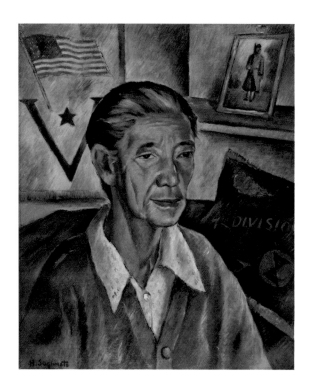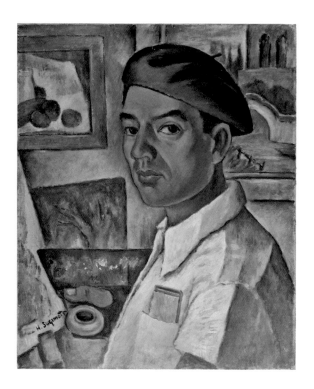

Henry Sugimoto
Mother in Jerome Camp (left)
Self Portrait in Camp (right)
1943
Oil on canvas, 22" x 18"
Japanese American National Museum

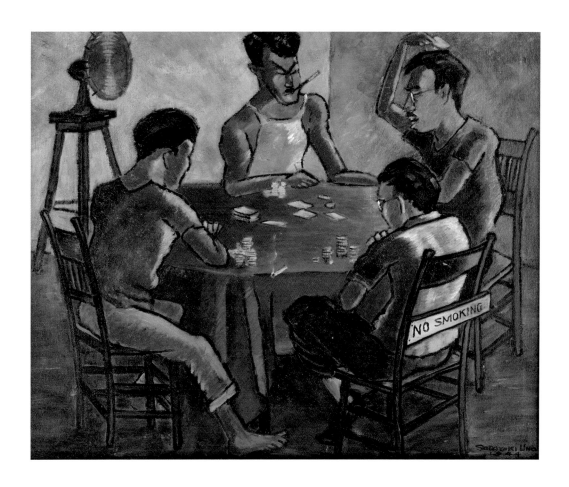

Sadayuki Uno
Untitled (men playing cards)
1944
Oil on canvas, 24" x 30"
Collection of Hisae Uno

82.

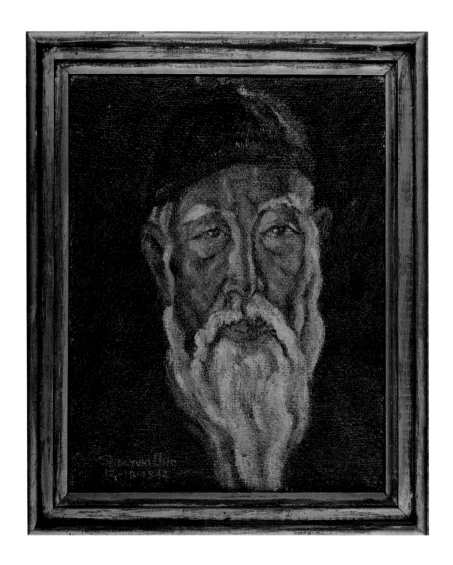

plate thirteen

Sadayuki Uno
Portrait of Nishida
1942
Oil on potato sack, 17.5" x 13.75"
Collection of Yo Kasai

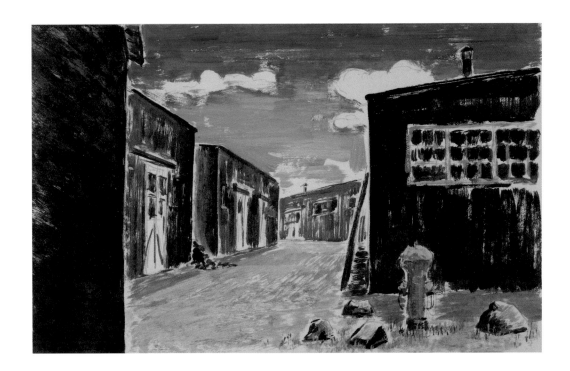

83.

plate fourteen

Kenjiro Nomura
Warehouses
1945
Oil on paper, 5" x 8"
The George and Betty Nomura Collection

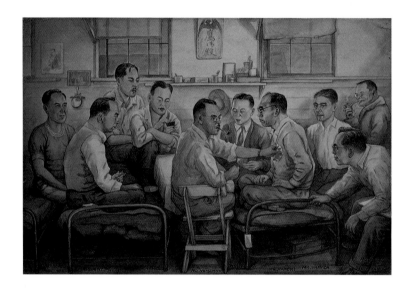
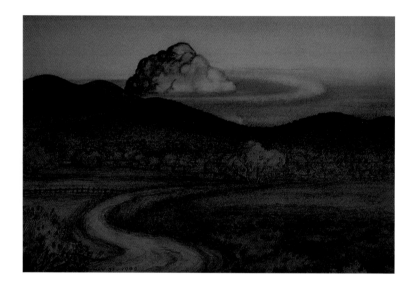

84.

plates fifteen & sixteen

Kango Takamura
Our Roommates (Santa Fe) (left)
At Evening Sketched this Beautiful Unusual Cloud Formation (right)
1942
Watercolor on paper, 15" x 22.75" and 10" x 15"
Department of Special Collections, University Research Library, UCLA

plate seventeen

George Hoshida
detail from *American World War II Concentration Camp Sketches, 1942 - 1943*
Loose leaf binder with eighty-five pages of drawings
and watercolors on paper
10" x 7.5" x 1.5"
Collection of Sandra Takahata

86.

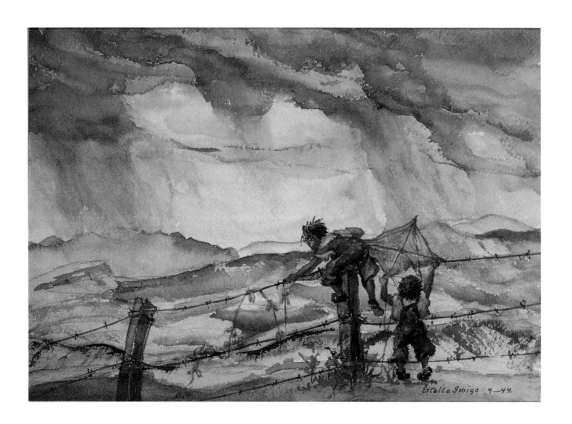

plate eighteen

Estelle Ishigo
Boys With Kite
1944
Watercolor on paper, 9.5" x 13.5"
Department of Special Collections, University Research Library, UCLA

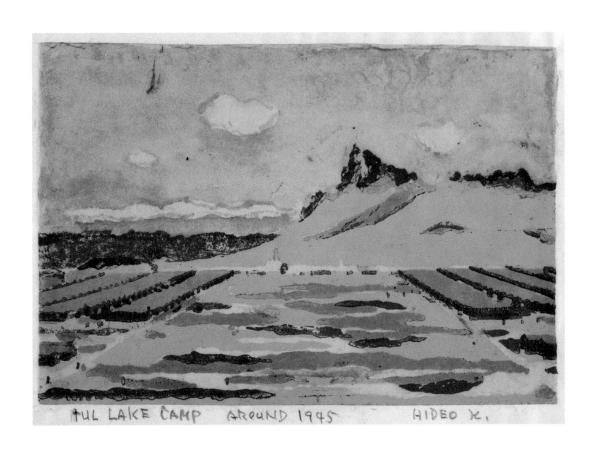

87.

plate nineteen

Hideo Kobashigawa
Tule Lake Camp
1945
Woodblock print with watercolor on paper, 6" x 9"
Japanese American National Museum

88.

plate twenty

Hideo Kobashigawa
Tule Lake Camp (sunflowers)
c. 1944
Oil on canvas, 30" x 25"
Japanese American National Museum

CHECKLIST OF THE EXHIBITION

Heizo Fukuhara

Untitled (man carrying wood), 1943
Oil on canvas, 15.5" x 19.5"
Collection of the artist

Henry Fukuhara

Manzanar Farm, 1942
Watercolor on paper, 11.25" x 15.5"
Gift of Henry Fukuhara,
Japanese American National Museum

Portfolio of 50 Scenes of the Relocation Centers, 1944
Printed paper, 6.25" x 9"
Gift of Mabel B. Hutchinson,
Japanese American National Museum

Taneyuki Dan Harada

M.P. Building Topaz, Utah, 1942
Oil on canvas, 16" x 20"
The Michael Brown Collection

Portrait of a Midget, 1943
Oil on canvas, 24" x 20"
Collection of the artist

Barracks, 1944
Oil on canvas, 22" x 28"
The Michael Brown Collection

Barracks Huddled Together, 1944
Oil on canvas, 20" x 26"
Collection of the artist

Tule Lake, 1945
Oil on canvas, 24" x 20"
The Michael Brown Collection

Barracks, Tule Lake, 1945
Oil on canvas, 26.75" x 31"
The Michael Brown Collection

Masamori Hashimoto

Tule Lake, c. 1942
Watercolor on organza, 38" x 17.5"
Collection of Shiz R. Hashimoto

Shunichi Hashioka

War Relocation Authority Hospital, Amache, Co., 1945
Watercolor on paper, 10.75" x 14.75"
Collection of Roy Hashioka

George Matsusaburo Hibi

Going for Inoculation, 1942
Oil on canvas, 16" x 20"
Department of Special Collections,
University Research Library, UCLA

Fracture (Satoshi), 1943
Oil on canvas, 26" x 22"
Estate of Hisako Hibi

Hisako, Wife, 1943 - 1944
Oil on canvas, 26" x 22"
Estate of Hisako Hibi

Topaz - Coyotes Come Out of the Desert, 1945
Oil on canvas, 26" x 22"
Estate of Hisako Hibi

Watch Tower, c. 1944
Oil on canvas, 22" x 18"
Department of Special Collections,
University Research Library, UCLA

Topaz WRA Camp at Night, 1945
Oil on canvas, 16" x 20"
Department of Special Collections,
University Research Library, UCLA

Men Painting, Sunset, Topaz, 1945
Oil on canvas, 20" x 24"
Department of Special Collections,
University Research Library, UCLA

A Cold Day, Topaz, c. 1944
Oil on canvas, 22" x 26"
Department of Special Collections,
University Research Library, UCLA

Untitled (guard tower and barbed wire fence),
c. 1943
Wood block print, 3.75" x 2.75"
Collection of Sue and Yukio Hayashi

Untitled (mess hall line), c. 1943
Wood block print, 3.25" x 3.5"
Collection of Sue and Yukio Hayashi

Untitled (guard and tower), c. 1943
Wood block print, 3.25" x 3.75"
Collection of Sue and Yukio Hayashi

Untitled (guard tower and coyote), c. 1943
Wood block print, 3.25" x 3.75"
Collection of Sue and Yukio Hayashi

Hisako Hibi

Laundry Room, 1943
Oil on canvas, 20" x 24"
Estate of Hisako Hibi

Homage to Mary Cassatt, 1943
Oil on canvas, 24" x 20"
Estate of Hisako Hibi

Topaz Farm Products, 1944
Oil on canvas, 26" x 22"
Estate of Hisako Hibi

91.

A Study #1, 1944
Oil on canvas, 20" x 16"
Estate of Hisako Hibi

Conversation, 1945
Oil on canvas, 20" x 16"
Estate of Hisako Hibi

Floating Clouds, 1944
Oil on canvas, 18" x 22"
Estate of Hisako Hibi

Topaz, 1945
Oil on canvas, 16"x 20"
Estate of Hisako Hibi

Hiroshi Honda

Untitled (internees in mess hall), c. 1942
Watercolor and gouache on paper, 13.5" x 15.5"
Honolulu Academy of Arts

Untitled (men and barracks), c. 1942
Watercolor and gouache on paper, 15" x 22.25"
Honolulu Academy of Arts

George Hoshida

American World War II Concentration Camp Sketches,
1942 - 1943
Loose leaf binder with eighty-five pages of
drawings and watercolors on paper,
10" x 7.5' x 1.5"
Collection of Sandra Takahata

American Concentration Camp Internees, Portraits,
1942 - 1945
Loose leaf binder with eighty-two pages of
drawings on paper, 10" x 7.5' x 1.5"
Collection of Sandra Takahata

Eddie Y. Imazu

Untitled (barrack scene), c. 1944
Oil on wood, 9" x 45" x .75"
Collection of Frances Etsuko Okura

Estelle Ishigo

Boys With Kite, 1944
Watercolor on paper, 9.5" x 13.5"
Department of Special Collections,
University Research Library, UCLA

Heart Mountain, Wyo, 1944
Watercolor on paper, 10.5" x 9"
Department of Special Collections,
University Research Library, UCLA

No Privacy for Women and Children, c. 1944
Watercolor on paper, 9.5" x 6.5"
Department of Special Collections,
University Research Library, UCLA

Three Drawings of Camp Life, 1942 - 1945
Pencil on paper, 18" x 22"
Department of Special Collections,
University Research Library, UCLA

Gathering Coal in Mid-Winter, 1945
Oil on canvas, 20" x 24.25"
Department of Special Collections,
University Research Library, UCLA

Frank Kadowaki

Parker Reception Center, Poston, Arizona, 1942
Oil on canvas, 10" x 14"
Collection of the Artist

Chikaji Kawakami

Untitled (Tanforan infield), 1942
Watercolor on paper, 12" x 18"
Collection of Joe Kawakami

Untitled (self-portrait with biwa), c. 1943
Watercolor on paper, 18" x 12"
Collection of Joe Kawakami

Hideo Kobashigawa

Wildflower of Manzanar in Common Glass, 1943
Watercolor on paper, 20"x 14"
Japanese American National Museum

Tule Lake (flowers in blue vase), 1944
Watercolor on paper, 18" x 14.5"
Japanese American National Museum

Tule Lake Camp, 1945
Woodblock print with watercolor on paper,
6" x 9"
Japanese American National Museum

Tule Lake Camp (sunflowers), c. 1944
Oil on canvas, 30" x 25.5"
Japanese American National Museum

Self Portrait, Tule Lake Camp, 1944
Oil on canvas, 33" x 29.25"
Japanese American National Museum

Tule Lake , c. 1945
Oil on canvas, 33.25" x 39"
Japanese American National Museum

Manzanar and Tule Lake Camp 1942-1946, 1991
Artist's book including ninety-eight drawings and
watercolors from 1942-1946, thirty-nine
drawings and watercolors based on memories of
camp
24" x 31" x 3"
Japanese American National Museum

Masao Kondo

Music Appreciating Night and Searchlight from Guardhouse,
1942
Crayon on paper, 9" x 11"
Japanese American History Archives

Art Class Outdoors, Santa Anita, 1942
Crayon on paper, 9" x 11.25"
Japanese American History Archives

Untitled (art class), 1943
Watercolor on paper, 8.75" x 11.75"
Japanese American History Archives

92.

Charles Erabu (Suiko) Mikami

Tule Lake, 1943
Watercolor on paper, 9.75" x 18"
Japanese American History Archives

Topaz, 1943
Watercolor on paper, 10.5" x 18"
Japanese American History Archives

Toyo Miyatake

Untitled (barracks), c. 1945
Oil on canvas, 18" x 24"
Collection of Archie Miyatake

Untitled, 1945
Oil on canvas, 20" x 24"
Collection of Archie Miyatake

Jishiro Miyauchi

Heart Mountain, 1945
Oil on canvas, 13.5" x 25.75"
Collection of Emily Kuwada Igarashi

Seizo Murata

Untitled (Issei man), 1944
Oil on board, 42.5" x 32.5"
Collection of Dr. Larry Nakamura

Dan T. Nishikawa

Honouliuli Women's Internment Camp, 1943
Pencil and crayon on paper, 10" x 13.5"
Collection of Mrs. Dan T. Nishikawa

Making Ring from Toothbrush Handles, 1943
Pencil on paper, 13.5 x 9.5"
Collection of Mrs. Dan T. Nishikawa

Kenjiro Nomura

Warehouses, 1945
Oil on paper, 5" x 8"
The George and Betty Nomura Collection

Fire Station, c. 1945
Oil on paper, 5" x 8"
The George and Betty Nomura Collection

Barracks and Recreation Hall, 1944
Oil on paper, 5" x 8"
The George and Betty Nomura Collection

Hospital, 1944
Oil on paper, 5" x 8"
The George and Betty Nomura Collection

Gymnasium, 1945
Oil on paper, 5" x 8"
The George and Betty Nomura Collection

The Prairie, 1944
Oil on paper, 5" x 8"
The George and Betty Nomura Collection

Chiura Obata

Talking Through the Wire Fence, 1942
Sumi on paper, 11" x 16"
Estate of Chiura Obata

Two Angels in the Rain – the First Students of the New Art School, 1942
Sumi on paper, 19.75" x 14.5"
Estate of Chiura Obata

A Sad Plight, 1942
Sumi on paper, 11" x 15.75"
Estate of Chiura Obata

The "Topaz Times" in Production, 1942
Sumi on paper, 8.75" x 11.75"
Estate of Chiura Obata

Entrance of Obata Dwelling in Topaz, 1942
Sumi on paper, 11" x 16"
Estate of Chiura Obata

Transplanting Trees from the Mountains to Topaz, 1942
Sumi on paper, 10.25" x 15.5"
Estate of Chiura Obata

Hatsuki Wakasa Shot by M.P., 1943
Sumi on paper, 11" x 15.75"
Estate of Chiura Obata

Dust Storm, Topaz, 1943
Watercolor on paper, 13" x 18.5"
Estate of Chiura Obata

Sunset, Water Tower, Topaz, 1943
Watercolor on paper, 15.5" x 20.5"
Estate of Chiura Obata

Mine Okubo

Evacuee Children, Many Were Born in the Camps, 1943
Charcoal on paper, 14" x 20"
Collection of the artist

Dust Storm, 1943
Charcoal on paper, 14" x 20"
Collection of the artist

Mother and Children – People Were in Shock, 1943
Charcoal on paper, 14" x 20"
Collection of the artist

Mother and Child – Telephone Poles, 1943
Charcoal on paper, 14" x 20"
Collection of the artist

Mother and Children – Crying Baby, 1943
Charcoal on paper, 14" x 20"
Collection of the artist

Tanforan Assembly Center – over 400 bachelors were housed in the grandstand, 1942
Ink on rice paper, 8.5" x 12"
Collection of the artist

Individual clotheslines were put up everywhere and anywhere, 1942
Ink on rice paper, 9" x 12"
Collection of the artist

The grandstand was used as the induction center – 300 to 350 evacuees arrived each day, 1942
Ink on rice paper, 8.5" x 11.5"
Collection of the artist

93.

A huge sign "Enjoy Acme Beer" stood like a beacon on the nearby hill, 1942
Ink on rice paper, 8" x 11.5"
Collection of the artist

Playground with sandbox and swings were built for the children, 1942
Ink on rice paper, 8.5" x 12"
Collection of the artist

One day the canteen sold yard goods and the women went wild, 1942
Ink on rice paper, 8" x 11.5"
Collection of the artist

Issei Workers, 1943
Color casein on paper, 15" x 20"
Collection of the artist

Dedication of Topaz Hospital, 1943
Color casein on paper, 16" x 20"
Collection of the artist

Katsuichi Satow

Gila River (Butte), c. 1944
Watercolor on paper, 11.5" x 19"
Collection of Hiroko Blakeslee

Yutaka Shinohara

Untitled (men in front of barracks, Santa Anita), 1942
Pencil on paper, 12" x 18"
Collection of the artist

Untitled (grandstand at Santa Anita), 1942
Pencil on paper, 12" x 18"
Collection of the artist

Henry Sugimoto

Documentary, Send Off Husband at Jerome Camp, 1943
Oil on canvas, 30" x 23.5"
Madeleine Sugimoto and
Naomi Tagawa Collection,
Japanese American National Museum

Making Our Mattress, 1942
Oil on canvas, 32" x 23"
Madeleine Sugimoto and
Naomi Tagawa Collection,
Japanese American National Museum

When Can We Go Home?, 1943
Oil on canvas, 32.5" x 23.25"
Madeleine Sugimoto and
Naomi Tagawa Collection,
Japanese American National Museum

Old Parents Thinking About Their Son on the Battlefield, 1943
Oil on canvas, 19.75" x 24"
Madeleine Sugimoto and
Naomi Tagawa Collection,
Japanese American National Museum

Self Portrait in Camp, 1943
Oil on canvas, 22" x 18"
Madeleine Sugimoto and
Naomi Tagawa Collection,
Japanese American National Museum

Rev. Yamazaki Was Beaten in Camp Jerome, 1943
Oil on canvas, 39.25" x 30.25"
Madeleine Sugimoto and
Naomi Tagawa Collection,
Japanese American National Museum

Mother in Jerome Camp, 1943
Oil on canvas, 22" x 18"
Madeleine Sugimoto and
Naomi Tagawa Collection,
Japanese American National Museum

Bombing of Relatives Homeland, 1945
Oil on canvas, 51.5" x 38.5"
Madeleine Sugimoto and
Naomi Tagawa Collection,
Japanese American National Museum

Kango Takamura

Our Roommates (Santa Fe), 1942
Watercolor on paper, 15" x 22.75"
Department of Special Collections,
University Research Library, UCLA

Our Pet Hawk Died on May 22, 1942
Watercolor on paper, 8.5" x 11.5"
Department of Special Collections,
University Research Library, UCLA

Our Guard in the Watchtower Became a Spring Baseball Fan, 1942
Watercolor on paper, 8.5" x 11.25"
Department of Special Collections,
University Research Library, UCLA

Progress After One Year, 1943
Watercolor on paper with photo inset, 8.75" x 12.75"
Department of Special Collections,
University Research Library, UCLA

Making Rice Cakes (Mochi-Tsuki), 1942
Watercolor on paper, 8.25" x 11.5"
Department of Special Collections,
University Research Library, UCLA

The First Successful Growing of Guayule, 1942
Watercolor on paper, 8" x 11.5"
Department of Special Collections,
University Research Library, UCLA

Mr. Akaboshi, 1943
Watercolor on paper, 10.25" x 14"
Department of Special Collections,
University Research Library, UCLA

Mr. Hirozawa, 1943
Watercolor on paper, 10.5" x 13.5"
Department of Special Collections,
University Research Library, UCLA

Some Characteristics of Guayule Strains, c. 1943
Watercolor on paper, 8" x 10"
Department of Special Collections,
University Research Library, UCLA

94.

Untitled Landscape - Winter, c.1943
Watercolor on paper, 15" x 20"
Department of Special Collections,
University Research Library, UCLA

At Evening Sketched this Beautiful Unusual Cloud Formation, 1942
Watercolor on paper, 10" x 15"
Department of Special Collections,
University Research Library, UCLA

Kamekichi Tokita

38-8-E Landscape, c. 1945
Oil on hardboard, 11" x 14"
Collection of Shokichi Tokita

Kakunen Tsuruoka

Untitled (mesquite trees), c. 1943
Watercolor on paper, 12" x 19.25"
Collection of the Tsuruoka Family

Untitled, c. 1943
Watercolor on paper, 13" x 20"
Collection of the Tsuruoka Family

Byron Takashi Tsuzuki

Forced Removal, Act II , 1944
Oil on canvas, 24" x 30"
Collection of August and Kitty Nakagawa

On the Way to Delta, 1944
Oil on canvas, 20.25" x 24.25"
Collection of August and Kitty Nakagawa

Playing Shogi No. 2, 1944
Oil on canvas, 20.25" x 24.25"
Collection of August and Kitty Nakagawa

Wash Day in Topaz No. 2, 1944
Oil on canvas, 16" x 20"
Collection of August and Kitty Nakagawa

Tokio Ueyama

The Evacuee, 1942
Oil on canvas, 24" x 30.25"
Gift of Kayoko Tsukada,
Japanese American National Museum

Untitled (barracks and basketball hoop), 1944
Oil on canvas on board, 18" x 24"
Gift of Kayoko Tsukada,
Japanese American National Museum

Untitled (clouds over barrack), 1943
Oil on board, 23" x 28"
Gift of Kayoko Tsukada,
Japanese American National Museum

Untitled (barracks with pond), 1944
Oil on canvas, 20" x 26"
Gift of Kayoko Tsukada,
Japanese American National Museum

Sadayuki Uno

Mussolini, Stalin, Hitler and Churchill, 1942
Carved pine, each 4" x 2" x 2"
Collection of Hisae Uno

Self Portrait, 1944
Oil on canvas, 24" x 20"
Collection of Hisae Uno

Portrait of Nishida, 1942
Oil on potato sack, 17.5" x 13.75"
Collection of Yo Kasai

Untitled (bridge), 1944
Oil on canvas, 24" x 20"
Collection of Hisae Uno

Untitled (guard tower), 1944
Oil on canvas, 20" x 24"
Collection of Hisae Uno

Untitled (men playing cards), 1944
Oil on canvas, 24" x 30"
Collection of Hisae Uno

Untitled (Jerome mess management award), 1944
Oil on canvas, 20" x 24"
Collection of Hisae Uno

Yoshiko Yamanouchi

Untitled (barracks at night), 1942
Watercolor on paper, 12.5" x 18.75"
Collection of Laura Watanuki

Jack Yamasaki

Thinning Sugar Beets, c. 1943
Oil on canvas, 15.5" x 19.5"
Collection of Dick Jiro Kobashigawa

Untitled (building brick structure, Heart Mountain), 1942
Ink and pencil on paper, 22" X 30"
Collection of Nobu Yamasaki

Untitled (barrack scene), 1942
Ink and pencil on paper, 15" x 21.5"
Collection of Nobu Yamasaki

Harry Yoshizumi

Untitled (Poston), 1945
Watercolor on paper, 15" x 22"
Collection of Emily Kuwada Igarashi

95.

BIOGRAPHIES OF THE ARTISTS

Heizo Fukuhara (1914 -) was born in Seattle, Washington. A Kibei, he attended grammar school in Japan, returning to Los Angeles as a high school student. Prior to the war he attended the Otis Art Institute. Fukuhara was interned in Manzanar and moved to Chicago as part of the early relocation program in 1944. The following year he was drafted into the army and served as an interpreter. He returned to Southern California and is retired.

Henry Fukuhara (1913 -) was born and raised in Santa Monica, California. He worked in his father's nursery business while attending the Otis Art Institute. During his internment in Manzanar, he was recruited to pick sugar beets in southern Idaho. Fukuhara resettled in New York and went into the wholesale florist business. He resumed painting upon retirement, and exhibits and teaches throughout Southern California.

Taneyuki Dan Harada (1923 -) was born in Los Angeles, California, and lived in Japan from 1931 to 1938. After his return to the United States, he was interned in Tanforan and Topaz where he studied under George Matsusaburo Hibi. Harada attended the California College of Arts and Crafts after the war. He participated in annual exhibitions sponsored by the Oakland Art Gallery, San Francisco Museum of Art, and the California Palace of the Legion of Honor. He received the James D. Phelan Award in 1949. By the mid-1950s, Harada stopped painting to raise a family and currently lives in Berkeley, California.

Masamori Hashimoto (1899 - 1980) was born in Okayama, Japan. He received some formal art training before immigrating to the United States in 1919 to live with his father and brother in Wyoming. After his family returned to Japan in 1922, Hashimoto moved to Washington, married, and worked in a lumber mill in Tacoma. He resumed painting during his internment in Tule Lake and Minidoka. Hashimoto returned to Tacoma where he worked as a gardener. His only paintings were done while he was interned.

Shunichi Hashioka (1884 - 1955) was born in Hiroshima, Japan, and immigrated to the United States around 1906. He was active in Japanese calligraphy clubs and ran a hotel in San Francisco's Chinatown. During his incarceration in Amache, he took classes from Tokio Ueyama. After internment he continued his interest in calligraphy.

George Matsusaburo Hibi (1886 - 1947) was born in Iimura, Japan. At the age of twenty, he immigrated to the United States. He attended the California School of Fine Arts (now the San Francisco Art Institute) from 1919 to 1930. Hibi participated in exhibitions of the San Francisco Art Association and the Oakland Art Gallery. He was interned in the Tanforan Assembly Center and in Topaz where he directed the art school. Many of Hibi's paintings and drawings are part of the collection of the Japanese American Research Project of the UCLA University Research Library.

Hisako Hibi (1907 - 1991) was born in a village near Kyoto and immigrated to the United States in 1920. She studied art at the California School of Fine Arts and participated in annual exhibitions of the San Francisco Art Association. She taught art during her incarceration in Tanforan and Topaz. Hibi resettled in New York City where she continued to paint while working as a dressmaker, domestic, and factory worker to support her two children. She moved back to San Francisco in 1954.

Hiroshi Honda (dates unknown) was born in Hawaii and sent to Kyushu, Japan, for schooling. Upon his return to Hawaii, he worked as a commercial illustrator. He was incarcerated in Sand Island, transferred to Jerome, and later to Tule Lake. After internment, the Honda family lived in New York City. Honda returned with his family to Hawaii but disappeared shortly thereafter. His family suspects that he returned to New York City to pursue his career as an artist.

96.

George Hoshida (1907 - 1985) was born in Japan. In 1912 he settled in Hilo, Hawaii, and worked for the Hilo Electric Company. Hoshida was interned in Kilauea Military Camp, Lordsburg, Santa Fe, Jerome, and Gila River. Hoshida resettled in Los Angeles where he worked as a deputy clerk in the municipal court of Los Angeles.

Eddie Y. Imazu (1897 - 1979) was born in southern Honshu and immigrated to the United States in 1910. He studied architecture at Berkeley for two years, but left to work in the film industry. He was incarcerated at Santa Anita and Jerome. After the war, he worked as an art director for Hollywood films including *Go For Broke*, a dramatic feature exploring the 442nd/100th Battalion.

Estelle Ishigo (1899 - 1990) was the Caucasian wife of Arthur Shigeru Ishigo, a Nisei. With the outbreak of war, Ishigo chose to accompany her husband into the camps. In the Pomona Assembly Center and Heart Mountain, she lived with other Japanese Americans. In Heart Mountain she worked as an illustrator for the WRA reports division and was granted permission to draw and sketch throughout the camp. Her drawings of the incarceration were published as *Lone Heart Mountain* in 1972. Ishigo was also the subject of a 1990 film documentary, *Days of Waiting*, by Steven Okazaki.

Frank Kadowaki (1900 -) was born in Shimane, Japan, and immigrated to California to join his parents who were farmers in Santa Ana. Before the war, he studied at the Otis Art Institute and continued to paint while interned in Poston. After internment, he worked as a restorer of Asian art in New York. Returning to California, Kadowaki ran the Asian art and antiques store for the Pacific Asia Museum in Pasadena until his retirement.

Chikaji Kawakami (1882 - 1949) was born in Kagoshima, Japan. He attended art school and took the name "*nampo*" (south side). In 1901 he immigrated to the United States and settled in Berkeley where he worked in a motorcycle repair shop and in a laundry and dry-cleaning business. Interned in Tanforan and Topaz, Kawakami moved to Chicago after the war.

Hideo Kobashigawa (1917 -) was born in Arizona and moved to Okinawa with his family as a young boy. At the age of sixteen, he returned to the United States. In Los Angeles he worked as a gardener and studied at the Otis Art Institute. Interned in Manzanar and later Tule Lake, he painted prolifically. After his release from Tule Lake in the spring of 1946, Kobashigawa moved to New York where he studied with Taro Yashima and at the Art Students League. Kobashigawa lives in Brooklyn and continues to paint, draw, and make artist's books.

Masao Kondo (1893 - 1973) was born in Tokyo, and immigrated to the United States at the age of twenty. He settled in the Los Angeles area and studied painting at the Otis Art Institute. He sketched and painted while interned in Santa Anita and Rohwer. After the war, he returned to the Los Angeles area. His art is in the collection of the Japanese American History Archives in San Francisco.

Charles Erabu (Suiko) Mikami (1901 -) was born in Hiroshima, Japan. He began studying *sumi-e* painting at the age of fourteen. In 1919 he immigrated to Seattle. He and his family were interned first in Tule Lake and later transferred to Topaz. During incarceration, Mikami actively painted *sumi-e*. After moving to Morgan Hill, California, he continued to do *sumi-e* painting and write *senryu* poems. His paintings can be found in the collection of the Japanese American History Archives in San Francisco.

Toyo Miyatake (1895 - 1979) was born in Japan and immigrated to the United States in 1909 to join his father. He began studying photography in 1918 and opened Miyatake Studios in the Little Tokyo area of Los Angeles in 1923. Miyatake is best known for his photographs of Manzanar taken with a wooden camera made with a lens and shutter that he smuggled into camp. Miyatake took photos secretly at first, and then later with the permission of the camp authorities. He was also interested in painting, and with the encouragement of his friends, including artist Tokio Ueyama, Miyatake painted in Manzanar and during the period immediately following his release.

97.

Jishiro Miyauchi (1888 - 1984) was born in Japan and immigrated to Vancouver in 1907 to work on the railroad. He held a series of jobs, from mine worker to dishwasher, before enrolling at the Chicago Conservatory of Music. He left Chicago to perform in vaudeville, singing Italian arias, and novelty songs. In Heart Mountain he focused on painting, making his own colors out of coal dust, rice paste, and natural pigments. After the camps, he continued to paint as an avocation.

Seizo Murata (1905 - 1960) was born in southern Honshu and immigrated to San Francisco. He graduated from the University of California at San Francisco in the 1930s with a degree in dentistry, and had an active practice in Japantown. Little is known about Murata; he has no surviving relatives. However, on his 1942 War Relocation Authority record form, he checked the category for "artists, sculptors and teachers of art" as a potential occupation. The painting in this exhibition is Murata's only existing work.

Dan T. Nishikawa (1906 - 1991) was born in Honolulu and educated in Japan. He returned to Hawaii in 1926, working at his family's store and as an advertising salesman for a Japanese language newspaper. He was incarcerated at Sand Island and Honouliuli, where he began sketching and making craft objects before being released in March 1944. After the war, he worked as a construction mechanic at the Dole Corporation.

Kenjiro Nomura (1886 - 1956) was born in Gifu, Japan. In 1907 he immigrated to the United States with his family and settled in Tacoma, Washington. When he was sixteen his family moved back to Japan, leaving him behind. In 1921 Nomura began studying with Fokko Tadama, a Dutch teacher and artist. He and his family were interned in Puyallup and Minidoka and returned to Seattle after internment. Nomura worked as a garment factory worker and in the framing business but was never able to make his living as an artist.

Chiura Obata (1885 - 1975) was born in Sendai, Japan, to a family of artists and decorators. He began his formal art training at the age of seven and apprenticed with painters of the Shinjo, Tosa, and Kano Schools. Obata immigrated to San Francisco in 1903 and joined the art faculty of the University of California at Berkeley in 1932. During his internment, he

founded the art schools in Tanforan and Topaz. After the war, he resumed teaching at the University of California at Berkeley until his retirement in 1954.

Mine Okubo (1912 -) was born in Riverside, California. She attended the University of California at Berkeley where she received her master of fine arts degree in 1936. She participated in exhibitions of the San Francisco Art Association and the San Francisco Museum of Modern Art, and was commissioned by the Federal Arts Program to paint murals at Government Island, Oakland Hospitality House, Fort Ord, and Treasure Island. While interned in Tanforan and Topaz, she taught art classes. Her book of drawings of camp life, *Citizen 13660*, was published in 1946. Okubo continues to paint and draw in New York.

Katsuichi Satow (1896 - 1992) immigrated to the United States in 1926 and settled in Idaho Falls, Idaho. From 1931 to 1941 he served as a pastor and Japanese language teacher in congregational churches in Coachella, San Diego, and Terminal Island, California. He painted watercolors and helped to develop educational and study materials for the public schools during his internment in Santa Fe and Gila River. After internment, he served as pastor in Cleveland, Ohio and later in Waimea, Kauai.

Yutaka Shinohara (1915 -) was born in Los Angeles, California. He lived in Japan from 1923-33, and attended art high school in Osaka. He moved back to Los Angeles where he worked at a noodle company and later operated a fruit stand in Hollywood. Shinohara was interned in Santa Anita and Heart Mountain. He resettled in Washington, D. C., and later returned to Los Angeles.

Henry Sugimoto (1900 - 1990) was born in Wakayama, Japan. In 1919 he immigrated to the United States. He attended the California College of Arts and Crafts, the California School of Fine Art, and the Academie Coroarossi in Paris, France. His work was exhibited at the Salon d'Automne in Paris, the California Palace of Legion of Honor, and the San Francisco Museum of Art. Interned in Fresno, Jerome, and Rohwer, he taught high school art classes. He resettled in New York and worked as an artist and fabric designer.

Kango Takamura (1895 - 1990) immigrated to the United States in 1921, lived in Hawaii and moved to the mainland where he worked for Paramount Studios in New York and for RKO Studios in Los Angeles. He was interned in Santa Fe and Manzanar. Takamura returned to Los Angeles and RKO Studios after the war.

Kamekichi Tokita (1897 - 1948) was born in Shizuoka City, Japan. He lived in Seattle, Washington, where he opened the Noto Sign Shop with artist Kenjiro Nomura. Tokita participated in exhibitions of the Oakland Art Gallery, the San Francisco Art Association, the San Francisco Palace of Legion of Honor, the San Francisco Museum of Art, and the Seattle Art Museum. He and his family were interned in Minidoka. Tokita later returned to Seattle and worked again as a sign painter. Few of Tokita's paintings have survived.

Kakunen Tsuruoka (1892 - 1977) immigrated to San Francisco as a teenager in the late 1910s. He worked as a dealer of Asian antiques while painting and making woodblock prints. In Poston he focused entirely on interpreting the desert flora and landscape through his paintings. He was also active in making craft objects of inlaid wood and set up craft displays in camp. Tsuruoka resettled in New York and resumed his career in the Asian antiques trade.

Byron Takashi Tsuzuki (1901 - 1967) was born in Hamamatsu, Japan, and immigrated to the United States during World War I. He studied art at Columbia University and the Art Students League. Tsuzuki participated in annual exhibitions of the Society of Independent Artists, the Salons of America, and Anderson Galleries of New York. He moved to California in 1932 and was interned in the Tanforan and Topaz camps. After internment, he returned to New York where he worked as a dental technician and artist until his death at the age of sixty-six.

Tokio Ueyama (1889 - 1954) was born in Wakayama, Japan, and immigrated in 1906. He attended art school in San Francisco, and received a bachelor's degree in fine arts from University of Southern California in 1914. In 1919, he graduated from the Pennsylvania Academy of Fine Arts. After travelling throughout Europe in 1920, he returned to Little Tokyo in Los Angeles. His work was exhibited at the University of Oregon, Fine Arts Society of San Diego, and the Los Angeles County Museum of Art. He continued to paint at Santa Anita and Amache, where he taught art classes. After the war he opened the Bunka-Do Gift Shop on First Street in Little Tokyo.

Sadayuki Uno (1901 - 1989) was born in Hiroshima, Japan. After finishing middle school, he and his brother immigrated to America to live with their father. Uno attended the California College of Arts and Crafts and the New York Photo Institute. He was interned in Fresno, Jerome, and Rohwer, and moved back to Oakland after the war. Uno worked as a gardener and was active in *shigin*, a form of spoken poetry.

Yoshiko Yamanouchi (1895 - 1973) was born in Osaka, Japan. In 1915 she immigrated to the United States and settled in San Mateo, California, where she established the first Buddhist Sunday School, Young Buddhist Association, and Women's Association. She also owned and operated a laundry business. Yamanouchi was interned in Topaz, and after the war returned to San Mateo where she resumed her laundry business. Yamanouchi did not have any formal art training.

Jack Yamasaki (1904 - 1985) was born in Kagoshima, Japan. At the age of eighteen, he immigrated to California to join his father, a farmer in the Imperial Valley. He studied art in San Francisco and at the Art Students League in New York before returning to Los Angeles in the late 1930s. Yamasaki was incarcerated in Santa Anita and Heart Mountain. After internment he joined the United States Army as a civilian; during that time he made sketches and drawings in India, China, and Japan. He continued to paint while supporting himself as a gardener.

Harry Yoshizumi (1922 -) was born in Watsonville, California and incarcerated in Poston, where he studied art. After the war he studied at the Art Students League, the California School of Fine Arts, and the California College of Arts and Crafts. In 1965 Yoshizumi gave up painting and worked at IBM for over twenty-five years. Now retired, he lives in San Jose.

99.

STAFF

Japanese American National Museum

Irene Y. Hirano, *Executive Director and President*

Nancy K. Araki, *Director of Community Affairs*
Eiichiro Azuma, *Japanese Language Curator*
Carlos Farfan-Pineda, *Maintenance*
Pamela N. Funai, *Collections Coordinator*
Norman Goya, *Museum Store Manager*
Clement Hanami, *Manager, Legacy Center*
Chester Hashizume, *Program Developer*
Karin M. Higa, *Curator*
James A. Hirabayashi, Ph.D., *Chief Curator*
Karen L. Ishizuka, Curator, *Photographic and Moving Image Archive*
Akemi Kikumura, Ph.D., *Director of Program Development/Curator*
Alison Kochiyama, *Manager, Public Programs*
Chris M. Komai, *Public Relations Coordinator*
Flo Kuraoka, *Development Manager*
Valerie Lee, *Accounting Manager*
Audrey T. Lee-Sung, *Membership Coordinator*
Jennifer Mikami, *Photographic Archive Assistant*
Lisa Miura, *Administrative Assistant, Office of Community Affairs and Public Relations*
Grace C. Murakami, *Registrar*
Hiro Nagahashi, *Public Relations*
Diane S. Nakagawa, *Program Development Assistant*
Grace Nakamaru, *Community Relations Coordinator*
Lily Oba, *Volunteer Program Assistant*
Florence S. Ochi, *Campaign Manager*
Karen Oshima, *Membership Assistant*
Teruo "Ted" Shida, *Director of Administration*
Norman Sugimoto, *Photographic Archive Specialist*
Layne Takemoto, *Administrative Assistant*
Heidi L. Tamayori, *Assistant to the Director*
Dorothy E. Tanaka, *Director of Volunteers*
Tricia Tao, *Campaign Assistant*
Sara Tomei-Iwahashi, *Traveling Exhibit Coordinator*
Mary Worthington, *Director of Public Programs*

UCLA Wight Art Gallery

Henry T. Hopkins, *Director*

Farida Baldonado, *Curatorial Assistant*
Ramona Barreto, *Education Assistant*
Ron Battle, *Installation Assistant*
Lynne Blaikie, *Preparator*
Patricia Capps, *Administrative Manager*
Laura Cogburn, *Community Development Assistant*
Bryan Coopersmith, *Graphic Designer*
Cindi Dale, *Director, Education and Community Development*
Joanne French, *Assistant to the Director*
Natalie Jacob, *Administrative Assistant*
Susan Melton Lockhart, *Registrar*
Vivian Mayer, *Publicist*
Maureen McGee, *Conservation Technician*
Terry Monteleone, *Director of Development, School of the Arts and Galleries*
Steven Montiglio, *Installation Assistant*
Jacqueline Myers, *Gallery Assistant*
Don Olstad, *Installation Assistant*
Dave Paley, *Installation Technician*
Will Reigle, *Installation Technician*
Ed Sarkis, *Installation Technician*
Elizabeth Shepherd, *Curator*
Keith Thomas, *Installation Assistant*
Layna White, *Assistant Registrar*
Jeri Williams, *Installation Assistant*
Regina Woods, *Outreach Coordinator*
Milt Young, *Exhibit Design/Technical Coordinator*

UCLA Asian American Studies Center

Don T. Nakanishi, *Director*

Cathy Castor, *Administrative Assistant of Center Management*
Enrique Dela Cruz, *Assistant Director of the Center*
Yuji Ichioka, *Adjunct Professor in History, Research*
Mary Kao, *Graphics and Production Coordinator*
Marjorie Lee, *Librarian and Coordinator, Library*
Russell Leong, *Editor, Amerasia Journal*
Gann Matsuda, *Coordinator, 50th Internment Commemoration Activities*
Brian Niiya, *Associate Librarian, Library*
Julie Noh, *Assistant Coordinator, Student Community Projects*
Glenn Omatsu, *Associate Editor, Amerasia Journal*
Sandra Shin, *Center Management, Administrative Assistant*
Jean Pang Yip, *Resource Development and Publications Manager*
Meg Thornton, *Coordinator, Student Community Projects*
Christine Wang, *Coordinator, Center Management*